THE WATERCOLOUR IDEAS BOOK

Joanna Goss

Contents

Introduction

Whether you are a beginner or a life-long artist, it is accepted that painting with watercolour gives way to personal and artistic expression. Find inspiration from the pages of this book on topics ranging from technique to style choice, or an intended mood behind an artist's work.

Contemporary artists working with water media impart a bit about their techniques, approach, or goal with their artwork throughout. Discovery is enjoyable at any age or stage in life, experiment and you will find that watercolour is accessible, fun and of course fluid. What is unique to watercolour is the immediate way it is executed – so much can happen when left to dry, or when interrupting wet paper with more wet applications of pigment. For some artists, a large part of their intention is to relax their approach and let water yield largely spontaneous results in their piece. Others have methods for working through intensive stages of colour methodical applications. Working with watercolour can be learned formally in school or shared between friends, but it is vital to any artist to first explore.

OPPOSITE: *Boho Boudoir*
by Bodil Jane

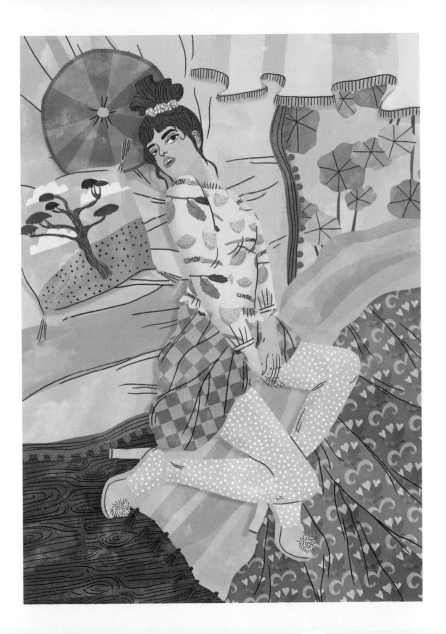

Greyscale

INSPIRATION #1
—

The female figure in Stina Persson's *Other Earring* is painted in greyscale. Her facial features are composed with minimal brush strokes of varying tones of black over a lighter, soft grey wash. While the painted image is created with a limited range of greys and a bit of violet, the added collage elements that frame her collar and fluorescent pink earrings have a mesmerising vibrancy, setting them apart visually.

OPPOSITE:
Other Earring

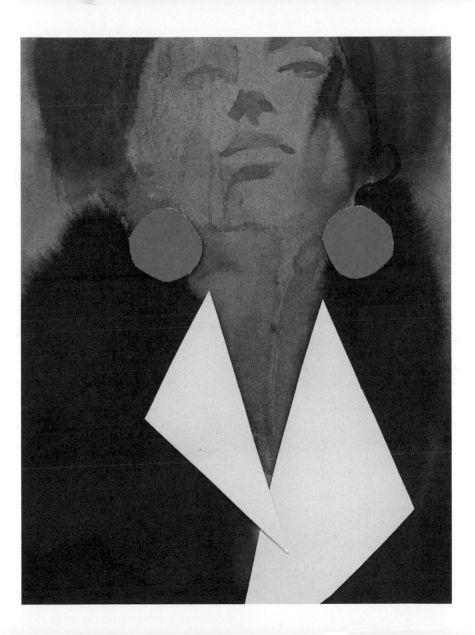

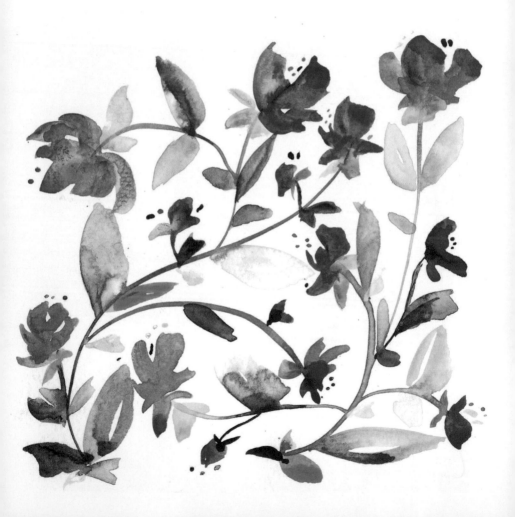

Positioning Your Brush

TECHNIQUE #1
—

Black ink painting is an ancient tradition originating in ancient China, with an emphasis placed on the beauty of individual strokes from one's brush. *Sumi-e* is the Japanese name for traditional black ink painting. Here, artist Kiana Mosley works intentionally with a sumi brush to create her highly gestural paintings. Changes in your pace and positioning your brush at varying angles on the page will produce thick and thin dynamic linework like those in *Nouveau Boheme no. 5*. Try holding your brush straight downwards on your page, working the tip to softly draw thin lines and then lay down the belly of the brush to the page and pull at a slight angle to create broader strokes.

OPPOSITE:
Nouveau Boheme no. 5

Working Vertically

TECHNIQUE #2

—

Picking up your painting invites the natural force of gravity to play a key role in crafting your composition. In *Daffodils*, by Kate Roebuck, layering transparent drops and washes adds visual and textural interest. By dipping your page occasionally, a gravitational pull will cause pigments to move across your page resulting in drips. Here, the artist applies a subtle wash of white, letting the drips become an integral part of the overall work. The washes appear to have a splattered bleaching effect.

RIGHT: *Daffodils*

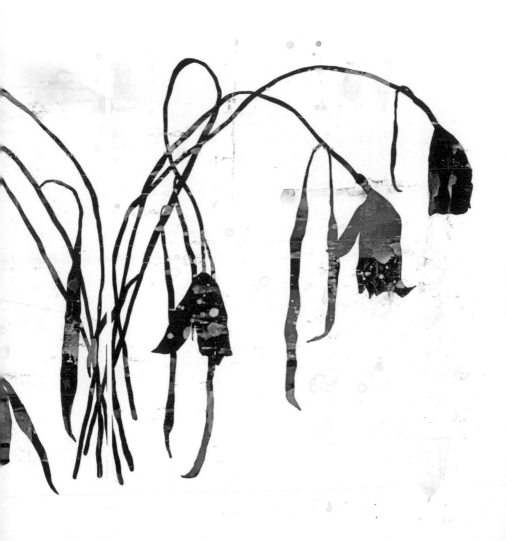

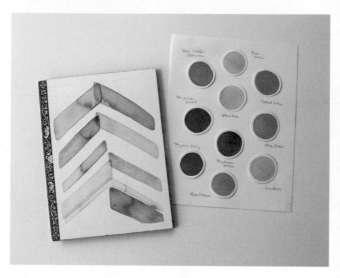

Creating Colour Swatches

INSPIRATION #2

—

Explore your materials. Some artists, such as Kim Wiessner, take great care to plot their colour choices in the lead-up time to beginning a painting. It can be useful to create your own colour swatches by simply testing a mix of colours and creating gradients to see how others change tonally on paper. By jotting down colour names and formula for a blend you can preserve a map that you can return to again and again when preparing to paint.

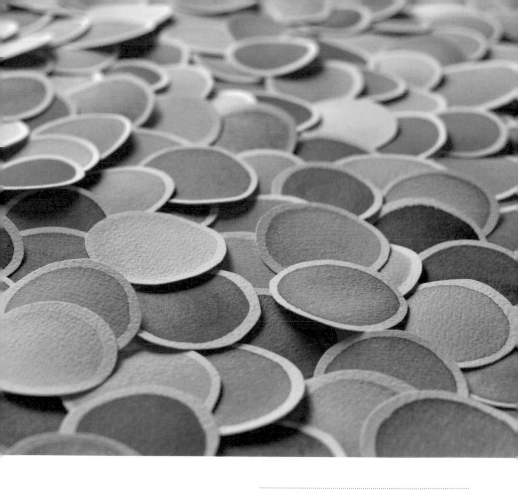

ABOVE & OPPOSITE: Creating your own colour swatches is an ingenious way of recording experimentation and exploration. *Paint dots* (above), *Pivot in Prism, Work in Progress* (opposite)

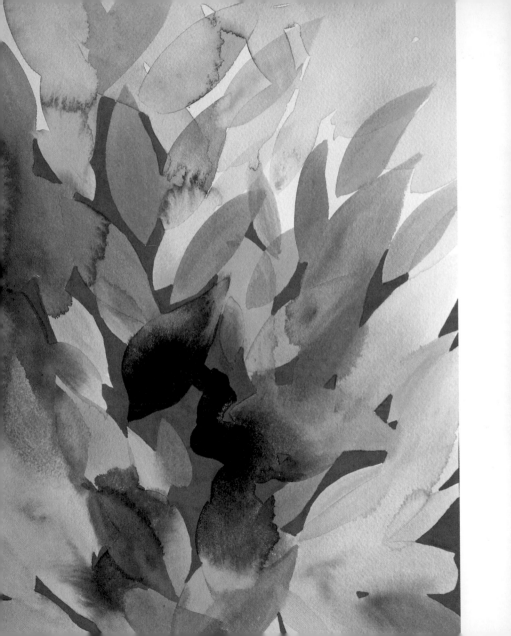

Opacity

TECHNIQUE #3

—

At the start, watercolour painting happens after you've mixed water and colour pigments, which contain a water-soluble binder. Watercolour pigments are sold in liquid and in dry form and simply varying the ratio of pigment to water is what creates your desired value of colour. Adding more water to your pigment will create lighter tones. In Helen Wells's painting, the leaf-like shapes to the centre-left are diluted to appear more faint. By contrast, the low shapes at the very bottom are very dark and opaque, achieved by adding less water to her pigments. The human eye is immediately drawn to a light element against a dark element. Those dark areas are attention grabbing and immediately become a focal point of interest.

OPPOSITE: *Verdant*

Glazing

TECHNIQUE #4

—

Overlaying transparent layers of watercolour on top of a wash of colour that has dried is a technique known as glazing. This technique allows you to make colour adjustments and also convey dimension in paintings. In *Color Grid*, by Elena Blanco, painted areas that appear brilliant and stand out apart from the rest have been painted with a single layer of colour. Those geometric cross-sections that appear to visually recede into the background are the areas where the artist added glazes, or secondary colour applications.

OPPOSITE: *Color Grid*

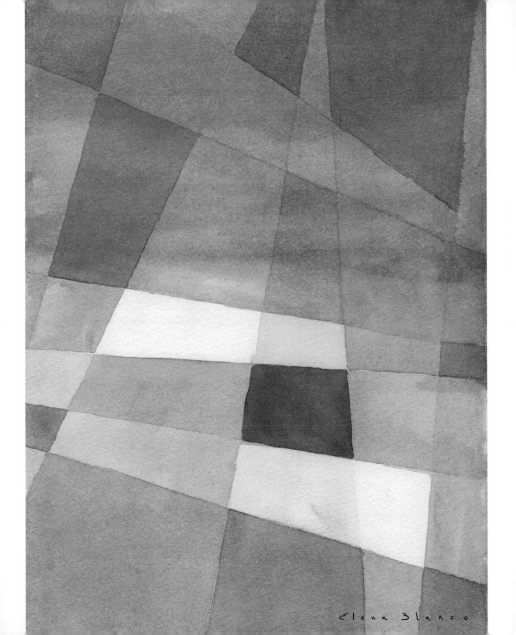

Elena Blanco

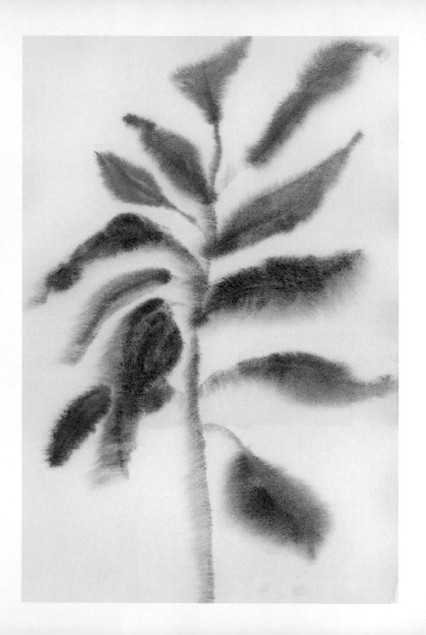

Wet in Wet

TEXTURES #1

—

The loose fluid feeling of this painting, *Hopper,* by Emily Grady Dodge, was achieved through applying the wet-in-wet technique. Heavier weighted papers are best suited for this style of painting. To achieve these flowing brush strokes, begin by saturating your paper with water. While your surface is wet, apply watercolours and watch as pigments disperse and travel across the surface of your paper. This will cause colours to collide and blend together. After the water evaporates, stained textures appear where pigments settle, creating beautiful spontaneity.

Line

TEXTURES #2

—

Lines are central to this painting, *Scribbles in Blue*, by Yao Cheng. When the artist executed each horizontal row with minimal strokes of a brush, she intentionally started out with her brush loaded with heavy dark pigment that eventually worked its way out and lighter areas of colour resulted. This causes a slight backwash of light blue areas bleeding into dark blue. It is difficult to detect a moment where the artist has lifted her brush. Movement and texture are effective, thanks to simple, repeated lines originating from the artist's brush.

OPPOSITE:
Scribbles in Blue

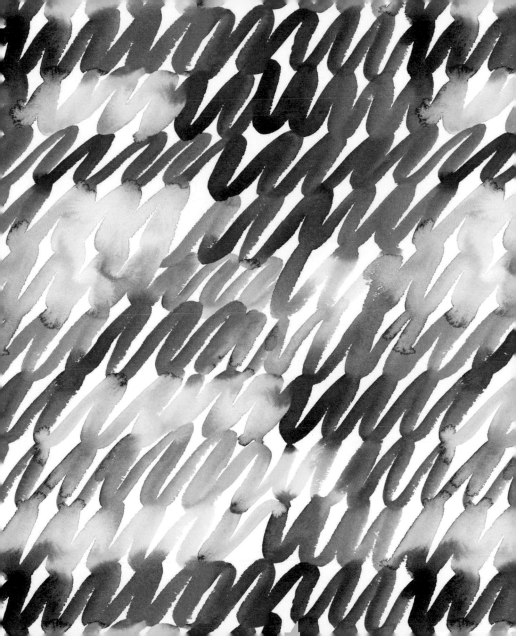

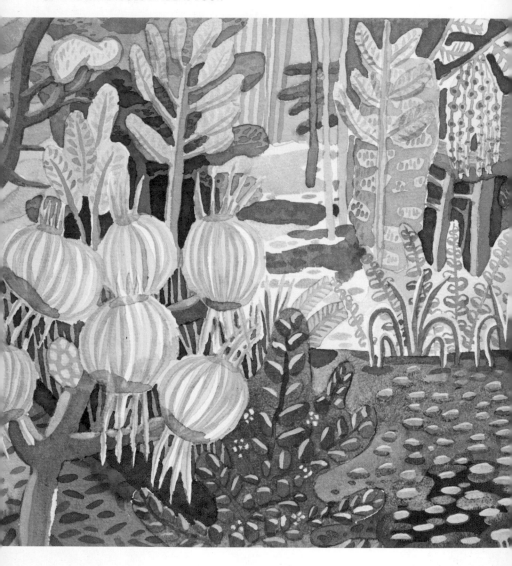

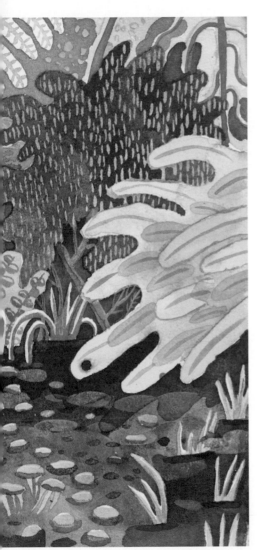

En Plein Air

STYLE #1
—

This work is known as a *plein air* painting. Working outdoors in connection with your surroundings makes your painting process spontaneous and enjoyable. Jennifer Tyers scouted her site before painting *Malaysia* over the course of one day. 'With watercolour every mark becomes part of the image, and nothing can be erased. I tend to relax about the process and everything is incorporated and evolves as the painting progresses.' Painting outside with this mindset sounds serene – I encourage you to give it a try!

LEFT: *Malaysia*

Masking

TECHNIQUE #5
—

There are a few different methods for resisting watercolour to preserve the white of your paper: you can draw with oil pastel, wax, or use a brush to temporarily block with masking fluid particular areas that you wish to remain unpainted. After your watercolour dries, as in this piece by Annabel Burton, you can easily peel away the masking fluid to reveal your preserved paper. This is especially helpful for preserving highlights and creating negative space.

OPPOSITE:
Violet Landscape

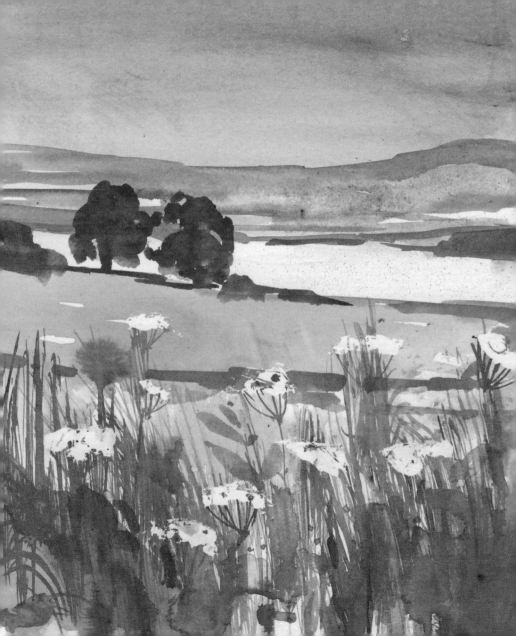

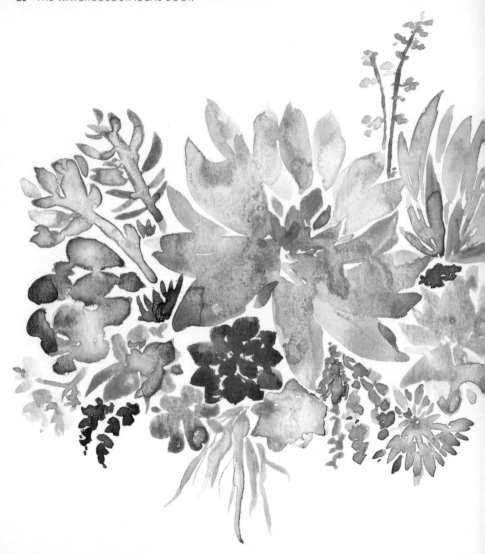

Using Different-Sized Brushes

COMBINING TECHNIQUES #1

—

Choosing watercolour brushes to suit your need will result in a more effortless painting process. There is a vast array of watercolour brushes on the market in an equally vast array of materials, sizes and shapes to achieve different effects. In this painting of a cluster of plants, artist Kiana Mosley transitioned through a few different brushes. The teal-green succulent is made up of tear-shaped, broad brush strokes, which resulted from pressing gently with a round brush. The mustard-coloured blossom to the right was created much the same way and with the same shaped brush, but of a smaller size. Choosing an even smaller round brush and working mostly with the tip, the artist pulled thin lines for the narrowest stems that you see. Also note that brushes come in a variety of shapes and natural and synthetic hair types, and vary in resilience, cost and performance. Try a few and you may happen upon a relatively lower cost brush that yields wonderful results.

..

LEFT:
Succulent Garden

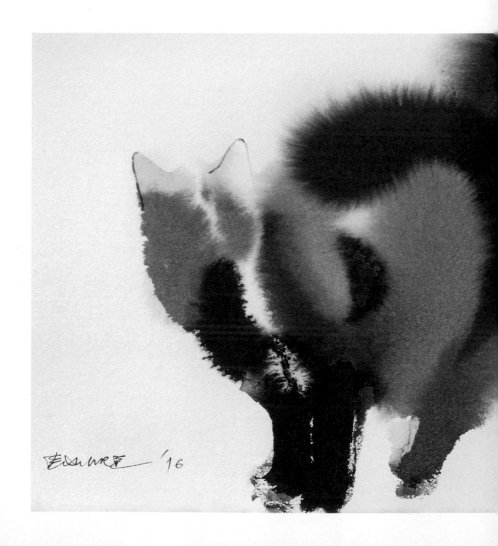

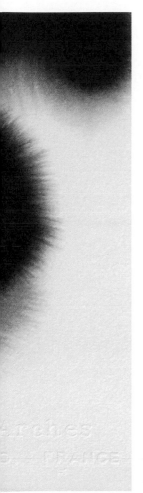

Water-Soluble Ink

STYLE #2

—

Working with black water-soluble ink can deliver unpredictable and wonderful results. Here Endre Penovác uses the wet-on-wet technique with black ink to create this fuzzy feline. Working with the immediacy of the medium, swift strokes of ink spread outwards from the points of contact on the page, creating an appearance of soft fur. After some mastery of the consistency of ink to water, as well as how best to wield his brush, the artist has developed a delightful manner for recreating the elegant posture of a cat.

LEFT:
Timid Kitten

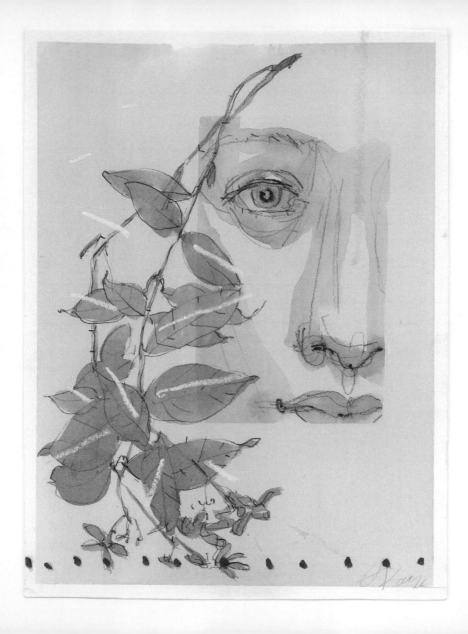

Water-Soluble Crayon and Watercolour

COMBINING MEDIA #1
—

At first glance, the lines in this mixed media piece appear to be made with graphite or charcoal, however they were drawn on using water-soluble crayon. These are reactive to water and can be used in either wet or dry applications. The dichotomy of sharply pulled lines and the staining quality of absorbed pigments are an intentional pairing by the artist. Annie Koelle uses a limited palette of muted green hues and red tones to paint down translucent layers of water media. When looking at the petals in the peachy blossom, she has captured a feeling of dimension by simply layering crayon to render petals in the form.

OPPOSITE:
Learning to Know 2

Exploring Media

INSPIRATION #3

There are many other water-based paint media available to try that produce similar effects to watercolours. The painterly strokes in this painting by Nicholas Stevenson, *Psychic Interiors*, were produced with gouache paint. Some may describe gouache as a paint that is both watercolour and acrylic. It comes in highly concentrated pigments that you manipulate with water to create degrees of translucency and opaqueness. If little water is added, your painting will have an opaque, matte surface. Though gouache is in some ways similar to acrylic, only some formulas are waterproof. To ensure your painting has a watertight surface you can simply mix gouache with a pure acrylic paint.

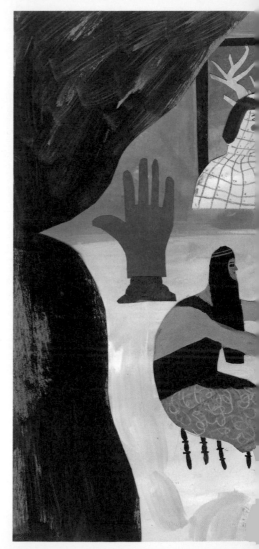

RIGHT:
Psychic Interiors

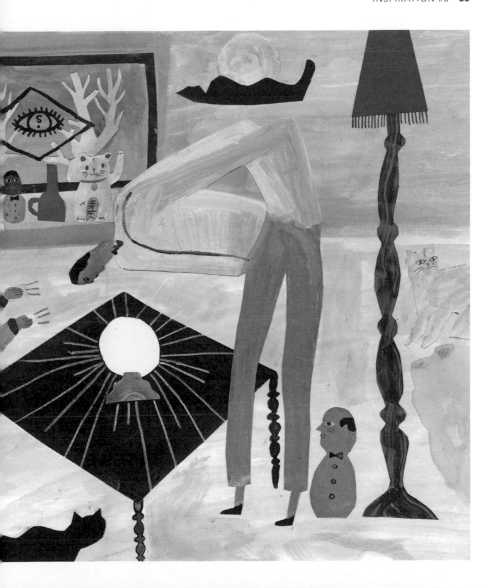

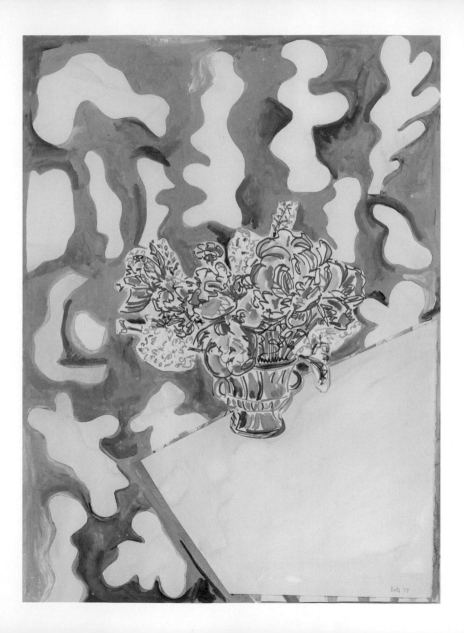

Collage

COMBINING MEDIA #2

—

By working with bits from multiple paintings, this tactile still life was assembled by Kate Lewis. In *Pink Flowers on White Table With Clouds*, watercolour paintings are cut and assembled into a collage. The large white piece of the table was applied with a strong angle to enhance the viewer's sense of vantage point. This unique angle allows the viewer to investigate the way in which the artist is interpreting her surroundings. A large area of the work is painted with cloud-like forms to resemble a wallpaper pattern in the backdrop. Rather than representing the actual background of her still life, painterly gradients of blue brush strokes draw interest from one white shape to the next.

OPPOSITE:
Pink Flowers on White Table With Clouds

Colour Shifts

APPLICATION #1

—

Colour gradients are lovely, and with some practice, can be very satisfying to achieve. This can be done by laying down washes of colour side by side with a flat brush, rinsing between colour applications. Once you have laid down a wash, tip your surface at a slight angle and you will notice a pool of water is collected and carries pigments, known as the bead. With just the right amount of water or by tipping your page, edges will blend seamlessly one into the next. This colour shift by Malissa Ryder was created within a wet-on-wet swatch on her paper, evident by the self-contained shape.

OPPOSITE:
Fanning Forms

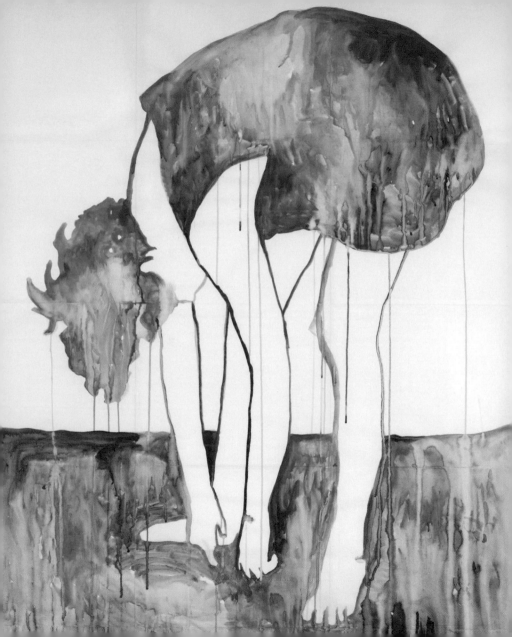

Figurative

STYLE #3
—

In this figurative painting, *Beuge*, Ulla von Brandenburg paints her muse with colourful watery brush strokes. A colourful figure is apparent, bent in a deeply bowed pose. The torso, head and hips of the figure are fully painted, while the limbs are outlined as they stretch to meet the colour-rich ground underneath. Vibrant colours inspire a curiosity about the subject's pose; is he or she stretching or surrendering?

OPPOSITE: *Beuge*

Illusion of Depth

TECHNIQUE #6
—

The illusion of depth is extremely effective in Justin Margitich's *V10*. The surface of the page is manipulated in such a way that it appears as though multiple planes were painted, rather than a single two-dimensional surface. The large amorphous cloudy shape at the centre seems to sit atop a higher plane than where vibrant bands of colour are painted. There are intentional slivers of white that the artist left unpainted, creating a visual cut-away effect. In the backdrop, a subtle gradient of grey emanates from the bottom of the page.

OPPOSITE: *V10*

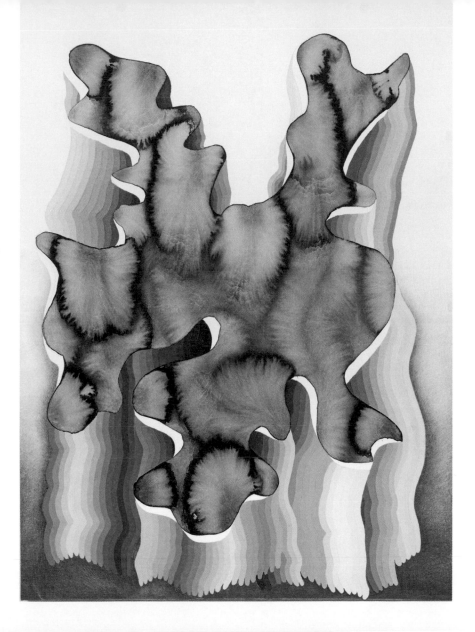

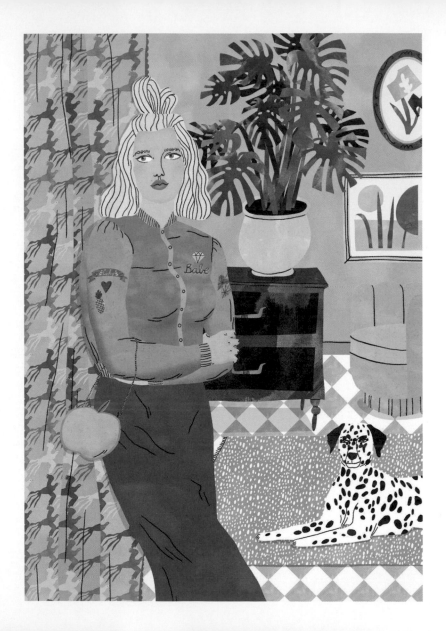

On-Trend

STYLE #4
—

Some artists find inspiration in translating modern trends in fashion and culture using water-based media. Interesting body postures, facial expressions and the colour palette and details in a certain style of clothing and accessories make women stand out in the works of Bodil Jane. She has a distinct style of simplifying hair and drawing out the corners of eyes that gives her female figures a hip, contemporary edge.

OPPOSITE: *Lucky Girl*

Dry Brush

TECHNIQUE #7

—

As the name suggests, this technique involves painting with a brush that has little to no water applied. Wet your pigments as you would normally, then test a few brush strokes on your page. With one pass over the white paper you will notice that your brush stroke seems partially absorbed, leaving a sparkling effect from visible white paper. This is especially apparent on rougher textured papers. Dry brushing can be very useful to add interest and energy to a painting whether used exclusively, to indicate highlights and reflections, or in addition to washes to create texture. Here Marzio Tamer enhances initial applications of colour with dry brushing, which successfully showcases the fine details of this tree.

RIGHT: *Grande Pino*

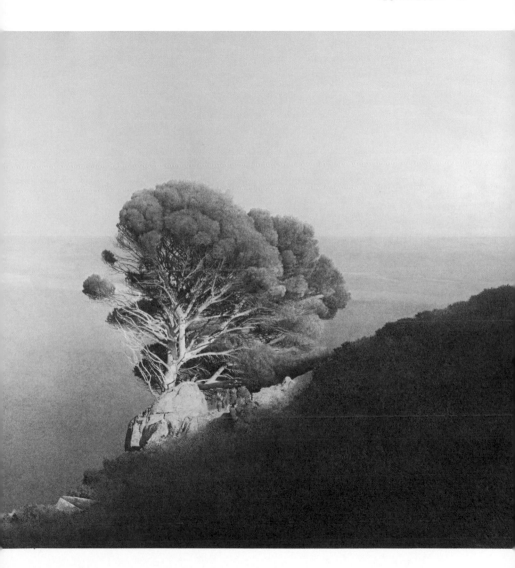

Positive and Negative Space

TECHNIQUE #8
—

In this piece, *University District No. 3*, the negative spaces are as essential to the work as those painted fully with colour. Those untouched spaces around the subject in your painting are something to give consideration to when crafting an image with any medium. There is an interesting shift from what you might expect to be painted, which is left untouched in this painting by Claire Cowie. Before beginning to paint, she carefully mapped out the areas of the paper that she wished to preserve. While meticulously painting around all of these areas, the white of the page depicts her leafy subject matter.

OPPOSITE:
University District No. 3

Perspective

INSPIRATION #4

—

Brooklyn Bridge demonstrates the visual impact perspective has on the viewing experience. Maja Wronska translates dimension and depth in her painting while conveying the size and position of all of the structures in view, in relation to one another. The precision of the linework helps to cement this ambitious work. Maja's extensive knowledge of structural planes and line is apparent in her delicately rendered watercolour paintings.

RIGHT:
Brooklyn Bridge

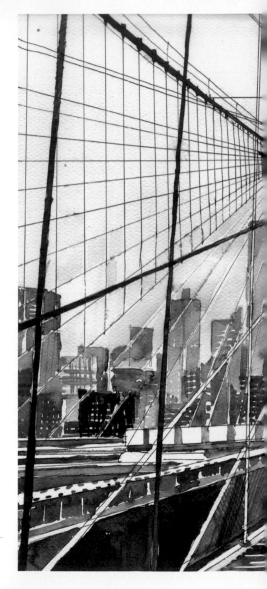

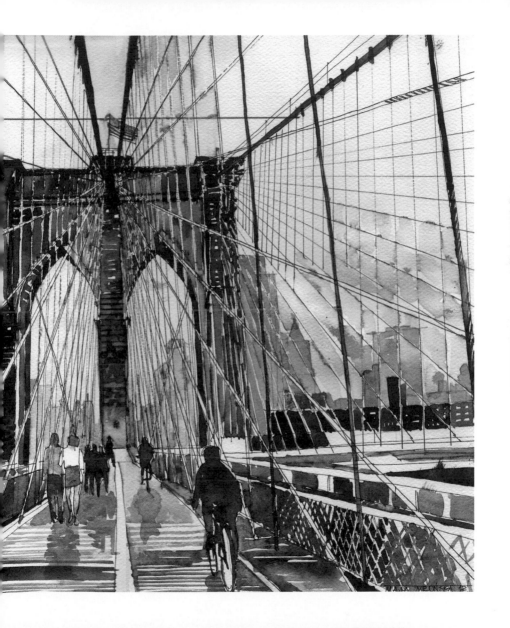

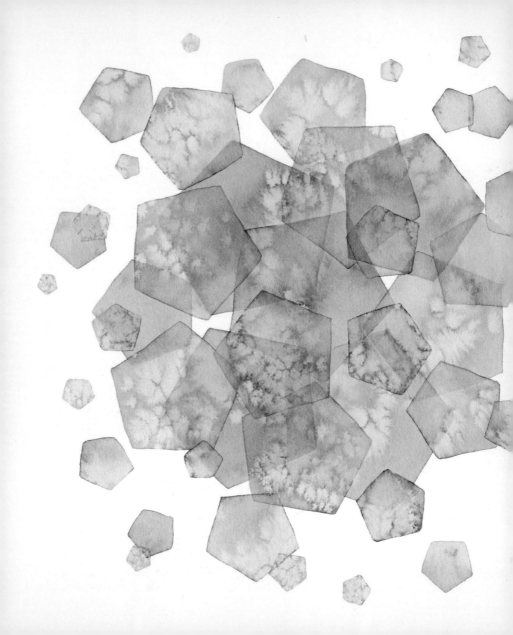

Salt

TEXTURES #3
—

Atmospheric and textural effects can be created by using a pinch of iodized table salt on your wet painting as artist Jen Lashek has done here. When applied to a wet wash, water and pigments are attracted to where the salt grains are scattered. Once the painting has dried, brush away the salt lightly by hand or with a dry sponge and notice the resulting crystalline textures.

LEFT:
Float in Blue

Light and Shadow

APPLICATION #2
—

Notice the effects of a given light source. The most pale
and luminous tones are those directly facing the light, while
colours darken gradually, moving away from the light source.
Marcos Beccari works from photographs to paint his subjects.
This individual is intentionally lit so the lightest parts of the
painting surround the eyes. He adds a succession of dark
tones to achieve detail in facial features. Areas of light and
dark give a three-dimensional illusion of form to the subject
matter. This method of applying paint is known as *chiaroscuro*
(literally 'light-dark') and has been employed by artists since
the Renaissance period.

OPPOSITE: *Sol ao Redor*

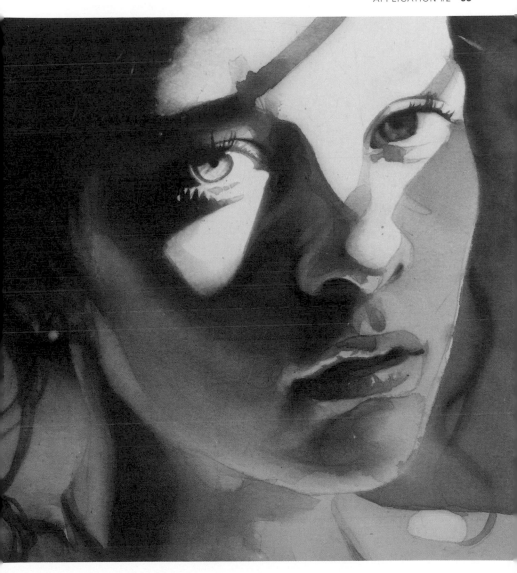

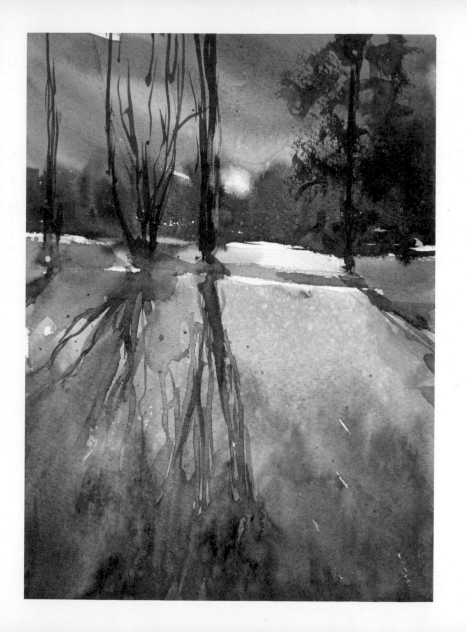

Splatter Textures

TEXTURES #4

—

Using rapid, expressive brush strokes builds momentum around your subject and helps convey an of-the-moment mood. The splatter effect is created simply by flicking the bristles of your brush at your paper. Working in this fashion not only conveys motion and texture, but indicates an immediacy with which the artist has committed their subject to paper. Artist Sarah Yeoman captured the light outside her window at the particular time of day in which she was observing it.

OPPOSITE:
*Morning Light from
the Studio*

Still Life

COMBINING MEDIA #3
—

Illustrating scenes from a cosmetic counter, artist Veronica Ballart Lilja created this grouping of objects on a reflective surface. In this contemporary still life, lipsticks are randomly aligned on a highly reflective makeup counter. Choosing a few vibrant colours, Veronica's painting is both realistic and impressionistic, with a bit of backwash evident in stains left from converging colours. The loose, watery textures in the tubes translate as a glossy and metallic sheen. The reflections from the lipstick tubes were reproduced digitally and added later in this composite image. If you search, you will notice striking similarities in some tubes as the artist reproduced some using software, slightly changing the orientation and size. This is a great method for illustrators to produce their desired outcome.

RIGHT: *Lipsticks*

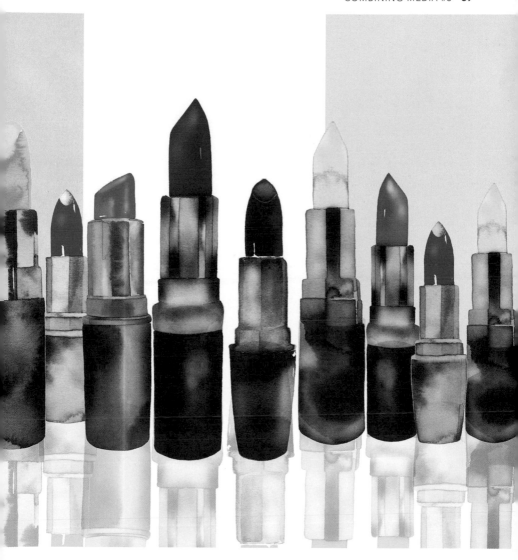

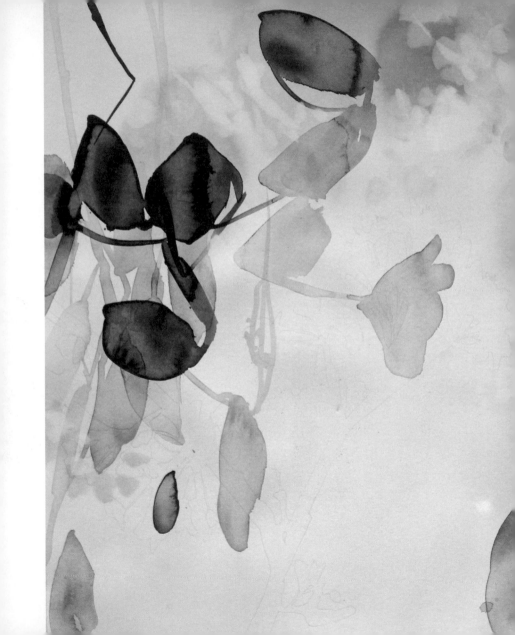

Balance

TECHNIQUE #9

—

In this painting, *Quiet Call*, by Elise Morris, balance is essential to the composition. The artist's dark leaf and stem-like strokes enter from the top left corner. An expanse of white negative space below occupies nearly the same amount of the painting. Bridging the two areas, the artist continues with a pattern of semi-translucent shapes in an arrangement that borders the page on all sides but the bottom. The artist has successfully distributed the weight of elements visually by placing heavier and lighter toned areas mindfully.

LEFT: *Quiet Call*

Yupo Paper

STYLE #5

—

Yupo is an interesting surface to paint on with water media. It is a paper made with plastic, so water is unable to be absorbed. This allows the water to flow freely, leaving it to pool and suspend pigments in different areas on the surface. When the water eventually dries, pigments are left to settle leaving very fluid brush marks. Some areas may even appear to be still wet, like the foliage in Randall David Tipton's *Poppies*.

OPPOSITE: *Poppies*

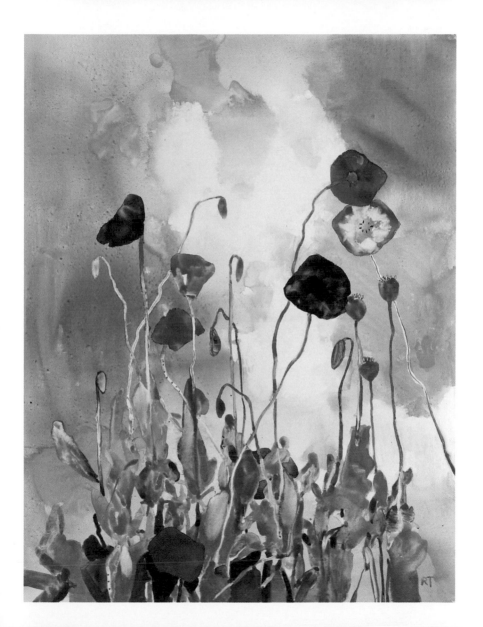

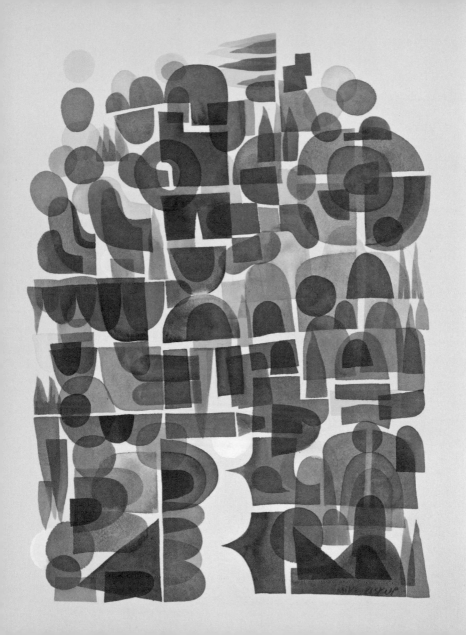

Layering Shapes

APPLICATION #3
—

Enjoy the process of developing your own unique vocabulary of shapes with which to compose a painting. Imagine these shapes are your building blocks for crafting a painting. This is a near-precise parallel to how Mike Biskup created *The Terra Flynn Effect*. This image was composed by layering simple shapes on top of one another. In overlapping areas you will notice a glaze over the original colour, where the artist let the underlying layer dry before progressing to the next.

OPPOSITE:
The Terra Flynn Effect

Using Metallic Pigments

COMBINING MEDIA #4

—

Mixing metallic pigments with your watercolour adds an unexpected glimmer. In this mixed-media piece by E.H. Sherman, the surface reflects as luminous. The artist intersects an expressive wash of indigo with a metallic gold medium. There is a range of metallic pigments that you can experiment with, including dry watercolour pigments, acrylic paints and gels. Keep separate brushes for painting with metallics as the pigments can be trickier to clean from your brush.

OPPOSITE:
Lapis Lazuli

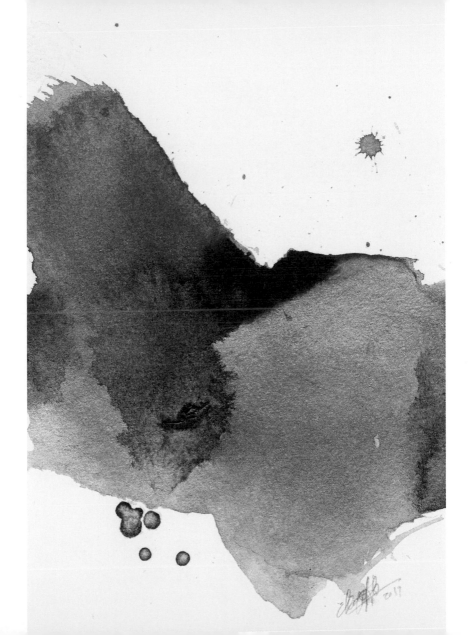

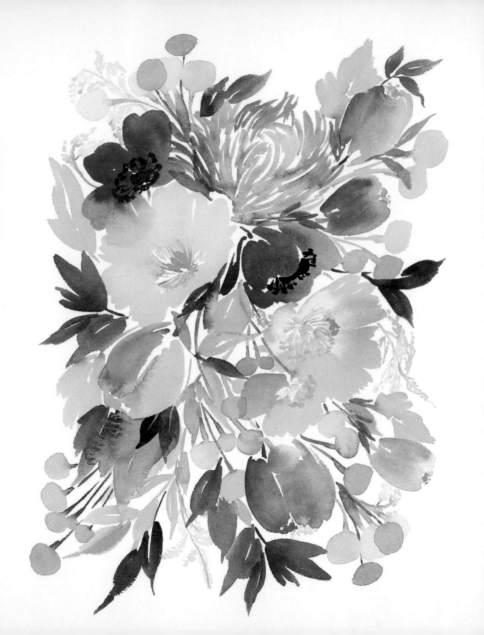

Painting Flowers

STYLE #6

—

Floral paintings are a signature subject for some artists, such as Yao Cheng, who expresses herself almost exclusively through the language of blooms. Much like your brush strokes, each petal is unique, so it's no wonder they are so often painted using water media. Some artists intend to capture each anatomical characteristic seen in nature while others develop a more stylistic approach, painting joyful representations of colourful blooms.

OPPOSITE:
Poppies Arranged

Dioramas

COMBINING MEDIA #5

—

Dioramas have served as scientific visual implements and have aided artistic expression for many years. They can be a joy to investigate, as is the case with *Beacon* by Allison May Kiphuth. The artist lovingly transforms empty cigar boxes and old crates into imaginative dioramas. Crafted with a mix of materials, her scenes depict tiny scenic woodland- and sea-inspired scenes.

OPPOSITE: *Beacon*

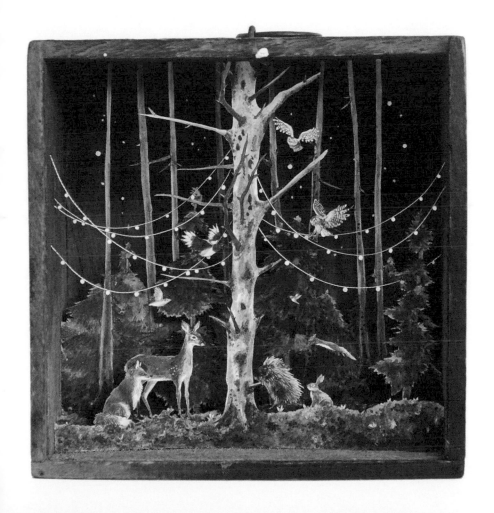

Photography and Watercolour

COMBINING MEDIA #6

—

Photography can be combined with watercolour media to draw attention to a particular part of the photo or enhance an intended mood. In *Labokoff Oiseau* the artist, Fabienne Rivory, invites the viewer to consider what is real versus what is imagined. The stained area of the photograph is painted in such a way that it suggests the reflection of a perceived landscape. Trees or mountainous terrain are really just stained edges of watercolour application. Or are they?

OPPOSITE:
Labokoff Oiseau

Fairytale and Fable

INSPIRATION #5

—

Literature and fantasy are worthy sources of inspiration, and artists have long created imagery influenced by classic works of fiction. Teresa Jenellen draws upon fairytales and fables to paint her subjects in close-up, capturing a moment wrought with emotion. *Red Riding Hood* is both a fanciful image of a character suggesting a sense of impending doom, and a portrait of a familiar, pale-faced girl who happens to be in a red robe.

OPPOSITE:
Red Riding Hood

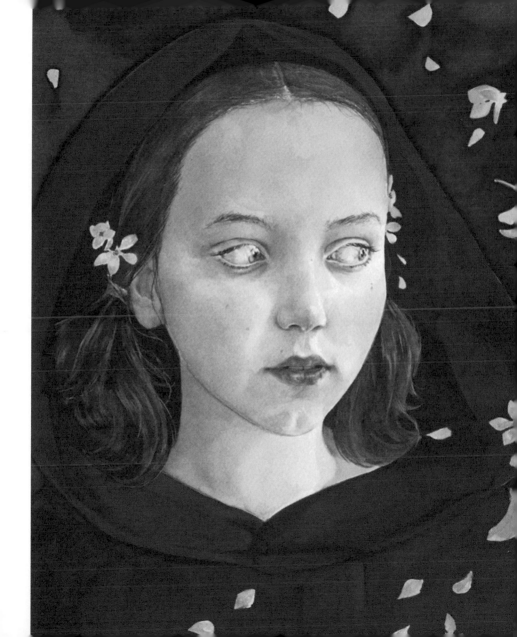

Embroidery and Watercolour

COMBINING MEDIA #7

—

Adding embroidery to your watercolour work provides another dimension and a more tactile experience for your viewer. *Apiary*, by Rhian Swierat, was composed in layers. The artist's focus is on her process. To begin with she paints with watercolour, letting a layer dry sufficiently, and then adds applications that dry at uneven rates, resulting in the light and dark tonal variation underneath. Her sewing is done by hand and is approached in a similar decision-making process as her painting – she is very intentional in the choice of the vibrancy, texture and consistency of her threads.

OPPOSITE: *Apiary*

Using a Flat Wash to Indicate Dimension

APPLICATION #4

—

By creating seamless flat washes of colour you're able to fill larger areas of your surface and efficiently indicate planes of a form, similar to those of artist Jen Lashek in this piece. The pairing of a flat wash brush and timing were instrumental to the artist to give a strong sense of three-dimensionality. The artist started by laying down simple geometric shapes with washes and then continued by adding more washes on all sides, after the original shapes dried. Visibility of lines where the shapes meet distinguishes the planes, or sides, to a form. The slight variation in colour and the repetition of flat shapes creates the illusion of stacked, semi-transparent cubes.

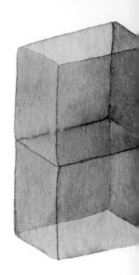

ABOVE: *Arranged 2*

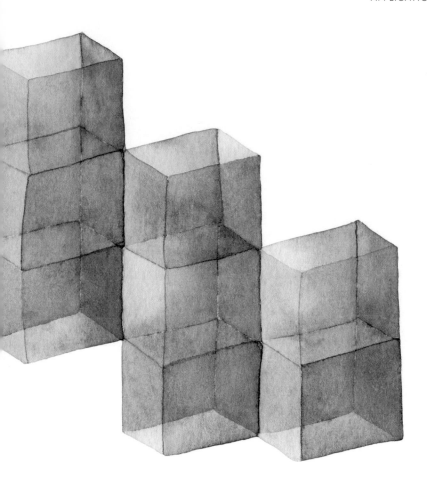

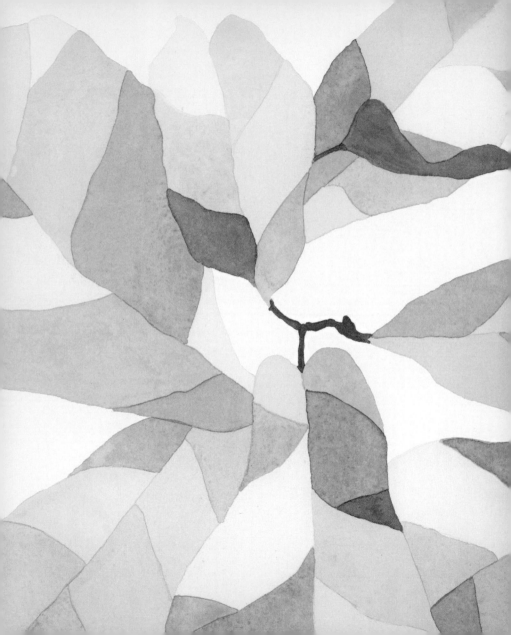

Complementary Colours

TECHNIQUE #10

—

When complementary colours are used side by side, like the yellow and violet in *Technicolor Fiddle Leaf Fig* by Emily Grady Dodge, one colour will cause the other to appear more bold. The artist bridges the tonal gap by painting certain sections of leaves with varying colour blends of peach and lavender.

Saturated Colour

APPLICATION #5

—

The way in which you apply colour
in your piece can create a visually
stimulating experience. To achieve
the opaque, saturated colours in
Where Should I Go?, Naomi Okubo
applied several layers of watercolours,
letting the layers dry between
applications. The details and colours
(especially the vibrant red) in this rich
composition are all key conductors
for attracting the eye to various points
within the composition. It is especially
fitting as the artist's intention is to
address the overpowering multitude
of options with which we may adorn
ourselves and our spaces.

RIGHT:
Where Should I Go?

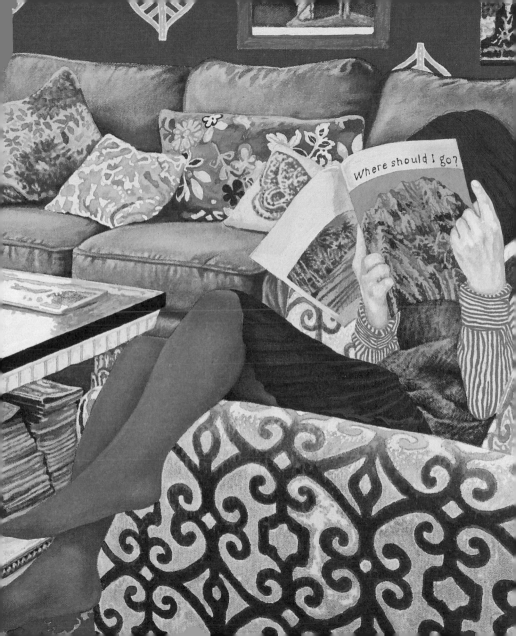

Where should I go?

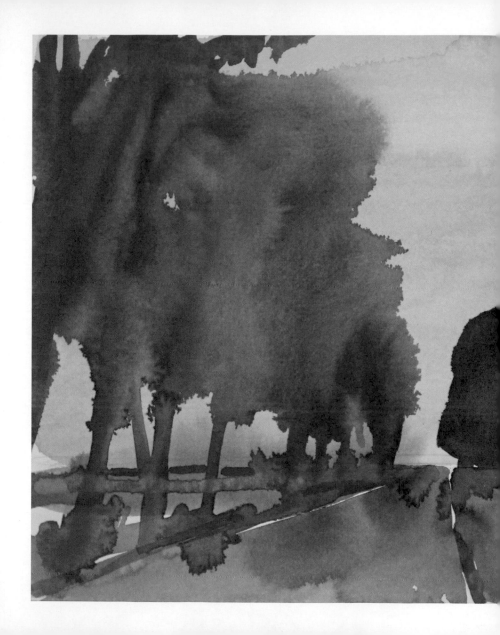

Creating Atmosphere

STYLE #7

—

Colour and painting style choices can be employed to convey atmospheric details. In this image by Rebecca Ryland, we observe a landscape set late in the day, or in the early morning, as indicated by the colour shift in the sky. The spectrum of colours in the treeline are painted wet in wet, as one colour collides into the next. The trees and land effectively flow together, creating a reflection. While detailed parts of the landscape remain ambiguous, an overwhelming feeling of atmosphere is observed.

LEFT:
Eldorado Bend

Miniature Paintings

STYLE #8

—

This small still life, *Kiwi*, by Heather McCaw Kerley, is only 3.5 " by 5 ". Though the subject is tiny, it is painted with undeniable depth. To indicate her light source, the artist leaves white light from the paper and rounds out the form with a few tones of colour. She has finished with a white stroke from a reflected surface.

OPPOSITE: *Kiwi*

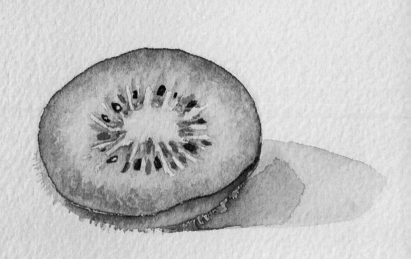

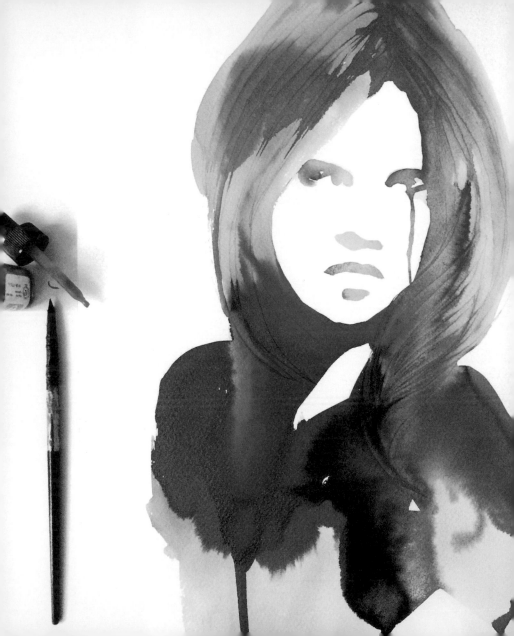

Stained Girl

APPLICATION #6
—

The wet application of highly pigmented inks lends itself well to a heightened sense of drama in this painting of a female figure. *Purple Blonde*, by Stina Persson has an impressive and immediate feeling of captivated beauty through the use of bold brush marks. Vivid colours and black dye-based inks are applied solidly against areas of untouched paper creating a bold contrast. The figure's expression and posture adds to her powerful presence on paper.

LEFT:
Purple Blonde

Cast Shadow

INSPIRATION #6

—

Although objects are the focal point in a still life, a cast
shadow provides support in translating depth and dimension.
Without a grounded surface to relate to, this mason jar would
float without context. Part of the enjoyment in this image is
viewing how Heather McCaw Kerley portrays the effect of
the light filtering through the blue glass of the jar.

OPPOSITE: *Tarragon*

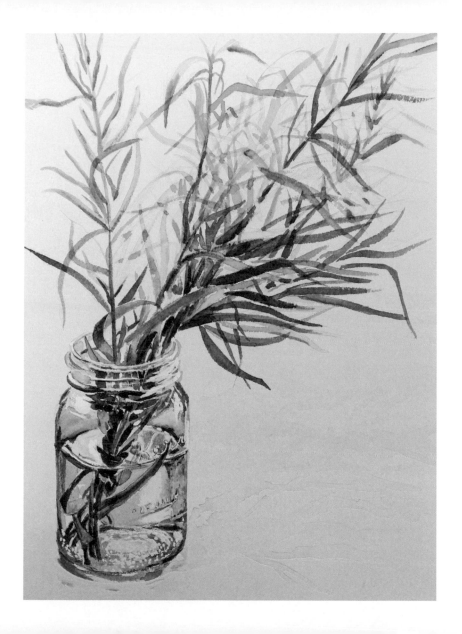

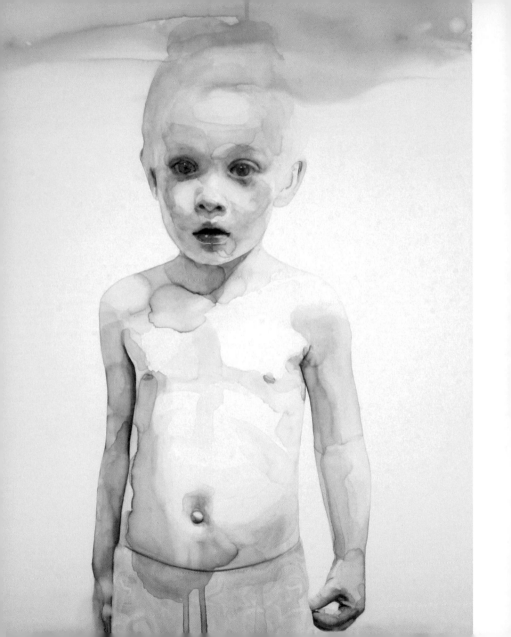

Portraiture

STYLE #9

Making portraits presents an opportunity for the artist to subjectively capture their subject, leaving behind a bit of themselves. The unique translucency of the watercolour medium suggests an innocence in Ali Cavanaugh's muse. The artist paints many portraits of women and children. Each of the artworks is distinguishable as hers, thanks to the same fluid layering of warm and cool tones.

OPPOSITE:
Surrounded By Your Voice

Diptych

STYLE #10

—

A two-part painting is known as a diptych. *Split Leaf Three Double*, by Kate Roebuck, consists of a mirrored representation of a tropical leaf. These are displayed in unison so the viewer is experiencing them as a whole work. It is interesting to note the related and unrelated qualities of the two monsteras. While the leaves are mostly symmetrical, there are variations in colour and texture, and a slightly altered shape revealing the artist's hand at work in the painting process.

OPPOSITE:
Split Leaf Three Double, and detail, below

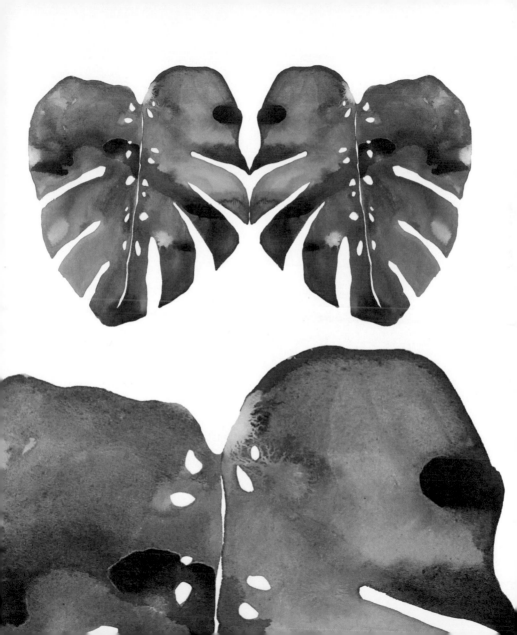

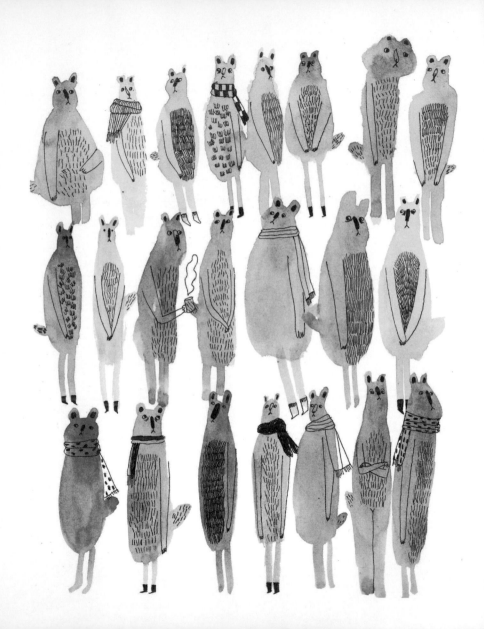

Creating Character through Detail

INSPIRATION #7

—

This clean composition of watercolour figures by Marion Barraud inspires an amusing narrative. The delicate ink detailing will leave you examining every last expression of her figures. It is incredible that so much narrative in each character can be created with thin lines and a bit of hatching with ink. The composition of the characters brings to mind observations that may arise when waiting in a queue.

OPPOSITE: *Bears*

Lifting Off

TECHNIQUE #11
—

In *Marilyn*, artist Nancy Louise Jones demonstrates control of the translucency and opaqueness by lifting off pigments. Working on Yupo paper, the artist has used materials like a paper towel to lightly blot and lift off pigments after watercolour was applied, creating an added layer of texture in the lighter areas.

OPPOSITE: *Marilyn*

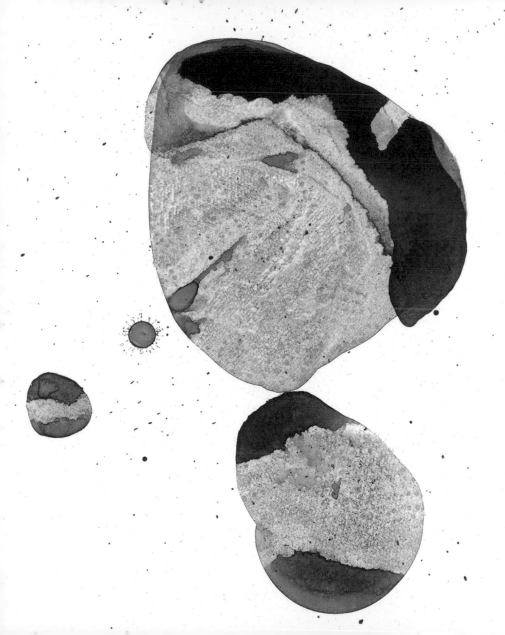

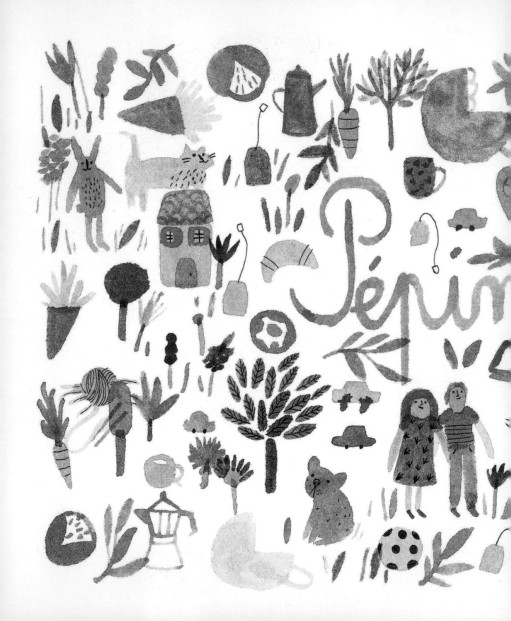

Everyday Objects

INSPIRATION #8

—

Everyday objects become the subject in this piece by Marion Barraud. The composition is filled with collections of cats, tiny houses, vegetables, kettles and more. This unexpected format showcases all the ways in which the artist produces small recognisable shapes with simple strokes from her brush. Though this is clearly not an investigation in proportion, the artist is more interested in a unique way to define all of the objects that interest her most.

LEFT: *Research*

Directing the Viewer's Eye

TECHNIQUE #12
—

In this painting by Kate Evans, the stark white line that signifies a road has huge visual impact. It is placed in the centre of the painting and is aimed directly where the viewer stands to observe the work. Your eyes will dart instantly from the open expanse of the foreground, which takes up nearly one third of the page, as your eyes journey another third of the way up the road, into the perceived distance. Once you've travelled this fast track you'll notice the details in the landscape on both sides and then you'll be drawn back to the road once again. The artist has intentionally used the road to direct the viewer's eye. This is a technique you can employ effectively in your own work.

OPPOSITE:
Escape Route

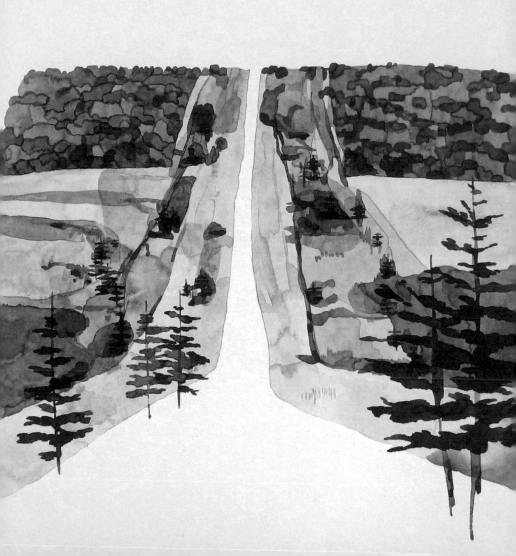

Coloured Pencils and Watercolour

COMBINING TECHNIQUES #2
—

Notice the textural lines added in coloured pencil to this cosy narrative piece. In *Reading Time*, Simona Ciraolo first applies a wash with warm tones of watercolour pigments to her background, leaving areas where light radiates from the lamp unpainted. Adding soft thick and thin alternating lines to create the pattern of the seat, Simona Ciraolo transitions to a simple red outline in her characters. The muted colour choices enhance the piece and the gestural linework lends a warmth and softness to the scene.

RIGHT:
Reading Time

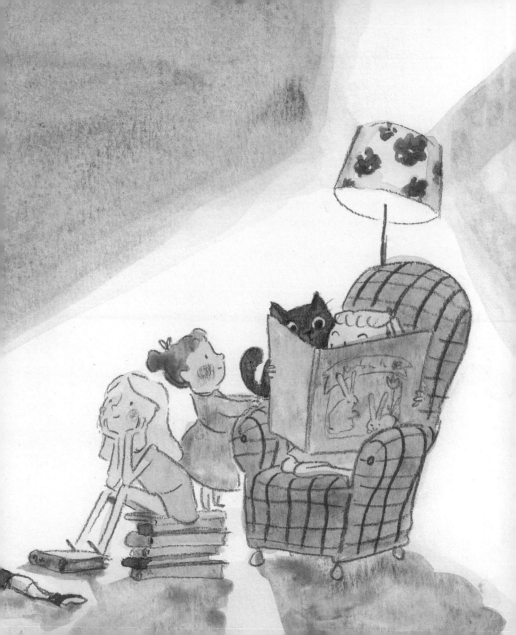

Watercolour with Screen-Printed Paper

COMBINING TECHNIQUES #3
—

These collages are made by incorporating pieces of the artist's hand-pulled screen prints. Traditionally, screen printing is a medium that allows for creating a large edition of a particular image. Watercolour is by contrast a medium that is new and unique each time you apply water and pigment to your paper. So many variables are at play with watercolour painting; the way the water evaporates and how pigments settle create a unique painting each time. To play with the two mediums together, as artist Amy Torgeson does, creates an exciting new form. Borrowing from her code of screen-printed patterns, she collages to create one-of-a-kind mixed-media artworks.

..

OPPOSITE: *Sketchbook*, Museum of Modern Art, Cuenca, Ecuador

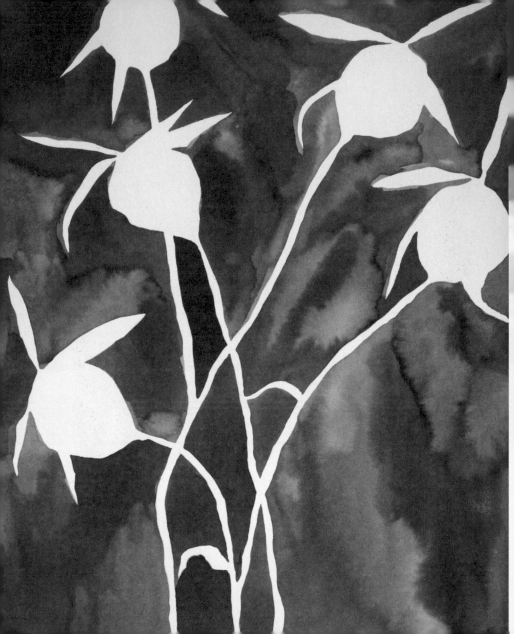

Handmade Paper

INSPIRATION #9
—

This painting, *Rosehips*, by Susan Hable was painted, using ink, on the artist's own handmade watercolour paper. Susan also works as a designer and a painter, and is connected to the very origin of her creative process. Susan works on handmade paper to achieve beautiful velvety saturation in the dark tones of blue. Susan's imagery often features plants and other ties to the natural world.

Stylised Figures

APPLICATION #7

—

Here the artist's muse is Saint Dwynwen – known as the Welsh patron saint of lovers. She is rendered stylistically with pointed fingers and nose, and patchwork hair. The colour choices and all the tiny shapes that make up the larger picture are all intentional choices by Jonathan Edwards as a part of his highly distinctive approach. The female character and her fox are a flat, harmonious part of the landscape. The artist's whimsical repertoire conveys a unique style of applying media.

OPPOSITE:
St Dwynwen

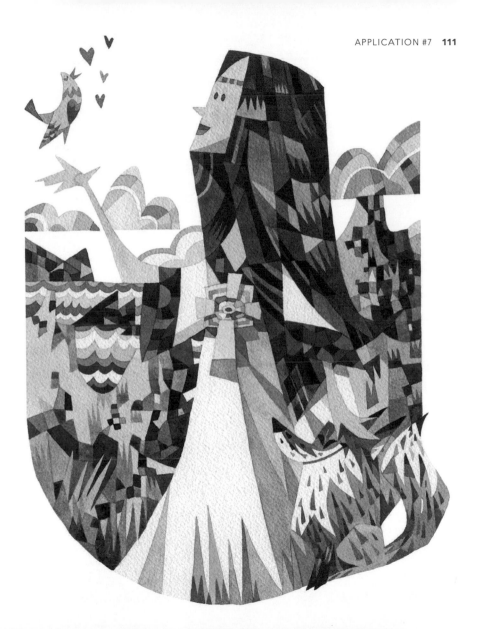

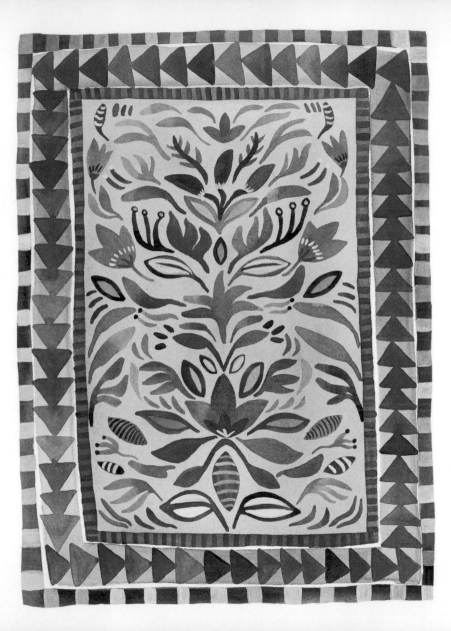

Symmetry

STYLE #11
—

Symmetrical imagery is found a lot in folk art. Mia Whittemore takes an interest in reimagining creative customs of the past in symmetrical designs. Rather than being precisely mirrored, the free-flowing perfectly imperfect feel is more interesting for the eyes to investigate, as well as more appropriate to her subject.

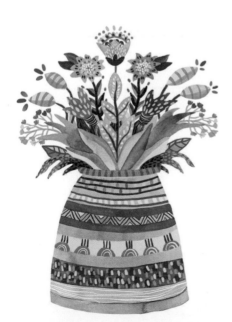

OPPOSITE:
Pink and Navy Rug
LEFT: *Folk Vase*

Painting Animals

COMBINING TECHNIQUES #4
—

Alisa Adamsone captures the lively
spirit of animals with gestural washes
of colour, allowing the colours to flow
one into the next. In *Michael*, the artist
has opted for vibrant pinks and blues
instead of hues from nature. Over the
top of her watercolours she has added
fine linework in varying thickness to
define features of the hare. Her stylistic
approach creates an alluring portrait of
a hare with a bit of personality.

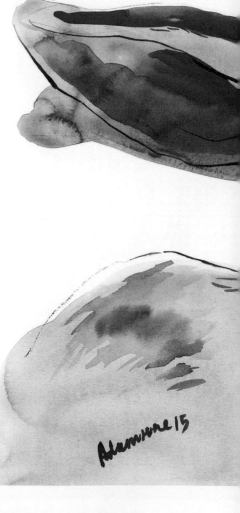

RIGHT: *Michael*

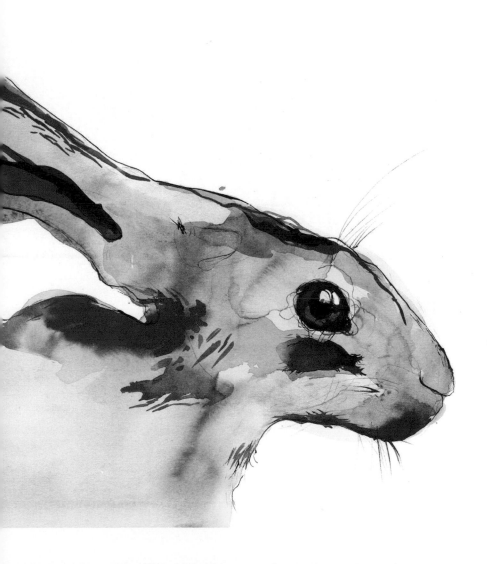

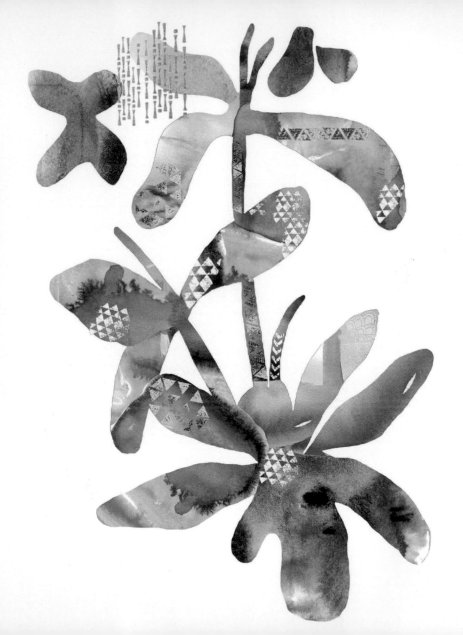

Digital Art

TEXTURES #5

—

This bright vivid floral appears to be a collage work. *Pastel Shapes* by Veronica Ballart Lilja was inspired by botanicals at a New York Market. The artist produced the components individually by hand with the added enhancement and efficiency of using computer software. The gold triangle pattern is a painted pattern that adds another level of surface pattern and texture. This process is vital to the vibrant images you often see in print and advertisements.

OPPOSITE:
Pastel Shapes

Painting on Claybord

INSPIRATION #10

—

Try experimenting with painting on different surfaces. A very intriguing surface to try is Claybord. The multi-layered clay panel is highly absorbent, but it also allows for quite a bit of manipulation of the paint. Some artists are able to paint and remove sections of their painting several times to reveal the clay, achieving the desired light tones or highlights in their work. Ali Cavanaugh applies aquamarine and flesh tone watercolour pigment on a wet clay surface using very small round brushes. The applications are loose and fluid, creating stunning translucent pools of texture.

OPPOSITE: *Left to Rise*

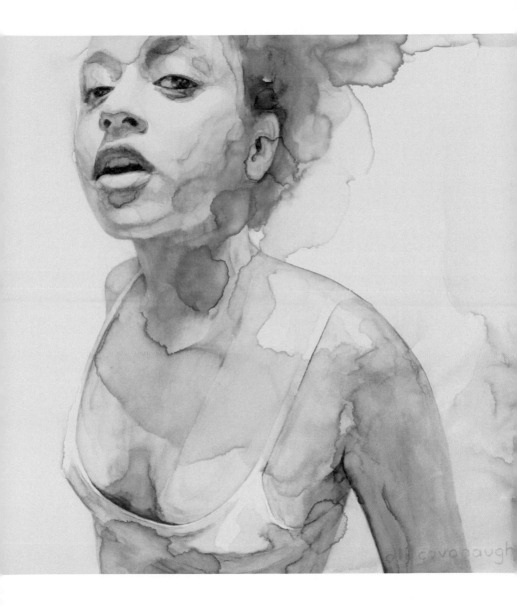

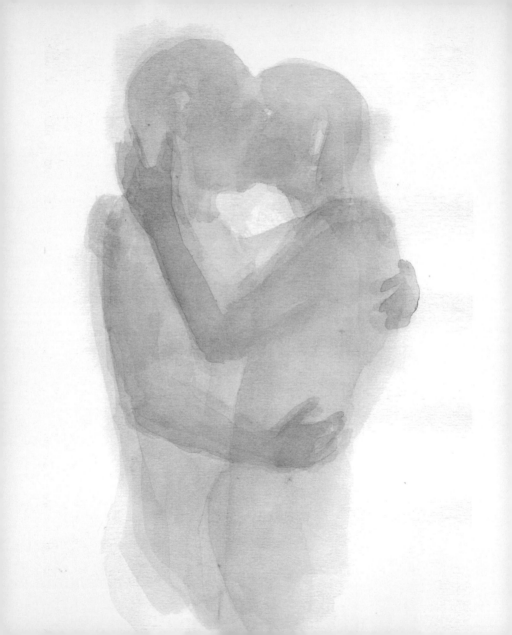

Monochrome

APPLICATION #8

—

Wide, rapid, monochromatic brush strokes illustrate human figures in an embrace. The artist, Francois Henri Galland, chose red as his singular pigment, and first applied a translucent wash with a liberal amount of water to map out the forms. Then subtle darker tones of red were added to sculpt the bodies. The colour dissipates and the forms melt into one another, adding to the dreamy quality of this image.

OPPOSITE:
Numériser 256

Movement

INSPIRATION #11
—

In *Layers*, by Elena Blanco, the artist paints smooth, sloped washes that transmit a steady ebb and flow sensation. The artist composed this tranquil piece by repeating visual cues such as a cool colour palette and overlapping similar transparent shapes. The viewer's eye traces the contours of each loose form, following downwards slopes and then effortlessly changing direction, guided by ascending lines. This brings about a wave-like, rhythmic sensation.

OPPOSITE: *Layers*

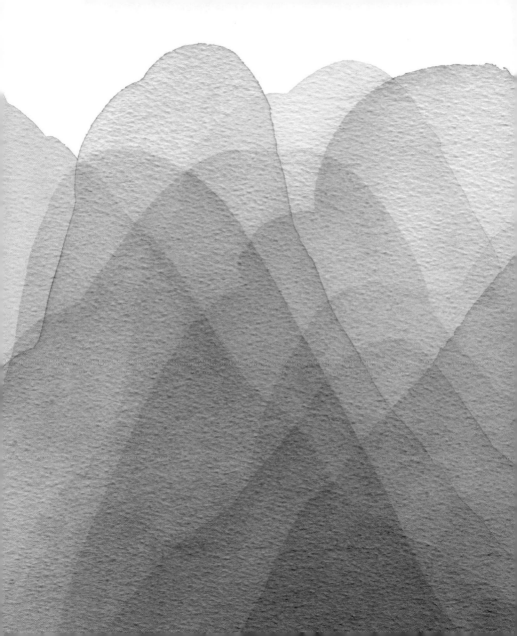

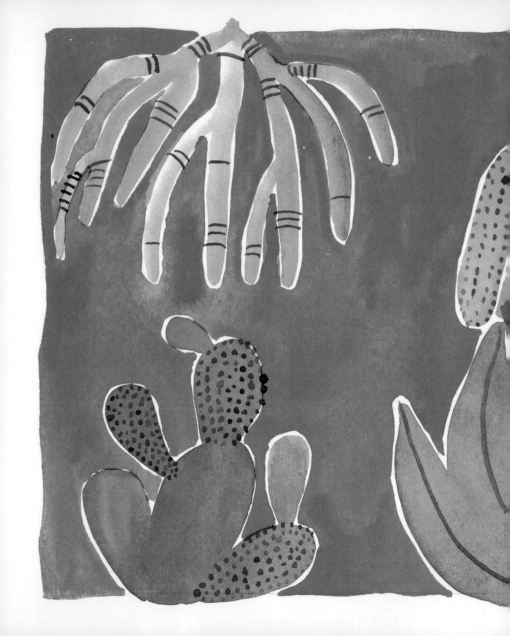

Warm and Cool Colours

STYLE #12
—

Red is a visually dominant colour, as it seems to advance in proximity to the viewer's eye. In this warm and cool coloured piece by Shelby Ling, two blue cacti are horizontally opposed to another pair. A striking visual pattern is produced by each occupying one quarter of the page. When the primary colours collide and mix together, there is a moment where a violet hue results at the tips of a cactus. The artist is less concerned with re-creating a landscape from nature, rather she is aiming to produce an eye-grabbing image.

LEFT: *Red*

Stained Edges

APPLICATION #9

—

In this piece by Karin Johannesson, captivating edges outline pink and yellow and red blooms, created by mixing colour pigments with a liberal amount of water. These wet pools of colour are drawn out with brush strokes to create loosely formed petals. With the amount of water used, a variety of one-of-a-kind edges remain where the water has evaporated. There are moments where negative spaces are filled in with splotches of colour. The centres of the flowers are painted while the entire bloom is wet, resulting in a fluid blending effect.

RIGHT:
Gardenia XIX

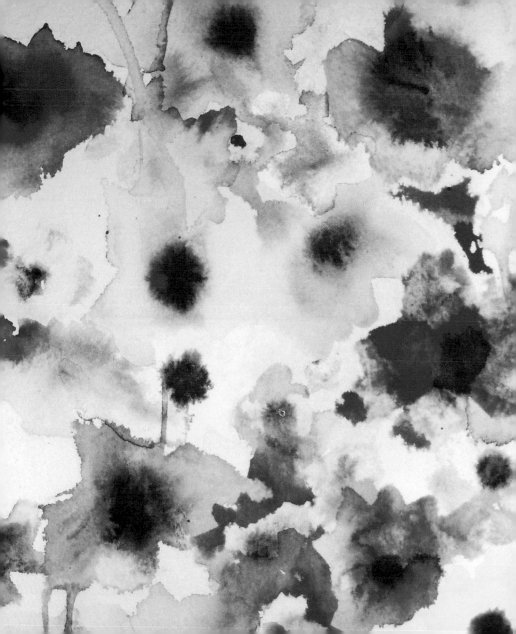

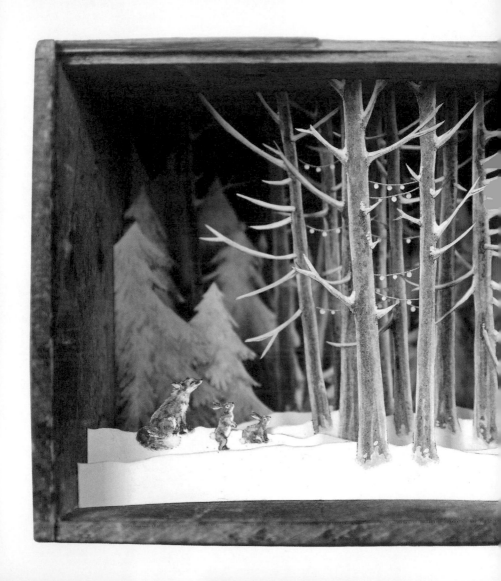

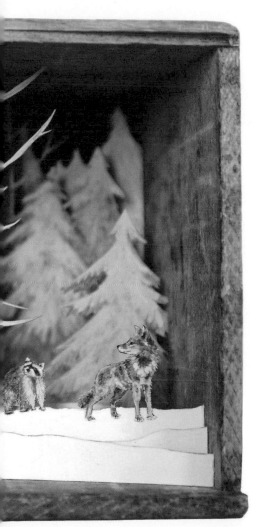

Adding Opaque White Details

COMBINING TECHNIQUES #5
—

In this piece by Allison May Kiphuth, the artist paints a scene of precious subjects from nature, giving details to patterns and textures. The white opaque detailing was done after the initial flat washes to paint the wood textures and fur of the animals were dry. The resulting visual effect appears as if fresh iridescent snow has naturally piled on top of trees and the forest floor. Opt for an acrylic or gouache paint to achieve the opaqueness so that the details fully cover the colour underneath.

LEFT:
The Spectators

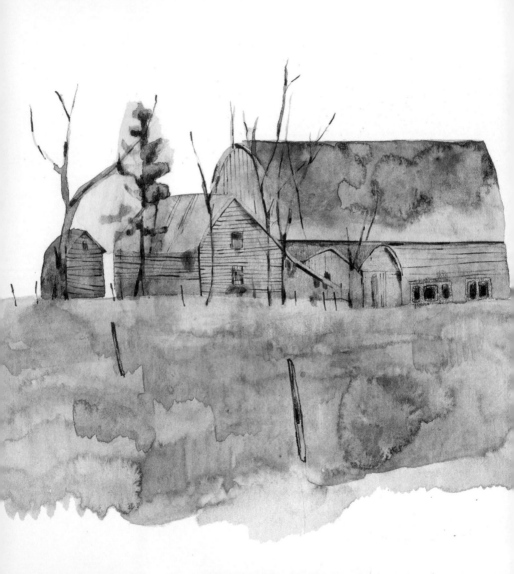

Using a Limited Colour Palette

COMBINING MEDIA #8

—

Artist Kate Evans uses a repertoire of both watercolour and oils, mixing a variety of hues from a select few pigments. The rolling meadow in the foreground of this landscape is created with a limited colour palette. It is interesting to note her choice to have the landscape appear against a vast blank space. The aim here is to draw attention to the isolated quality of this aging farm surrounded by remote landscape. The warm colours in the foreground keep the composition in balance visually.

LEFT: *Farm*

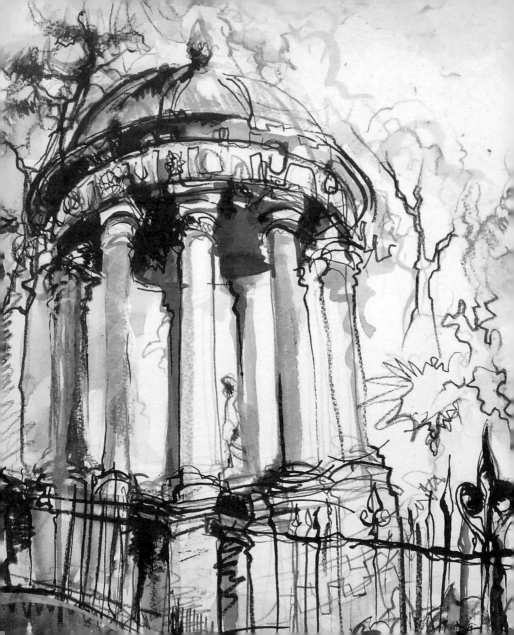

Foreground

APPLICATION #10

—

The author's intuition and style go hand in hand in crafting this image, *St Bernard's Well*. Lucy Jones pulls gestural lines in ink and also applies washes and blends watercolours, letting applications converge. Ultimately she allows the composition to inform her next decision as to where to apply the next medium. A collector of old books and maps, she creates 'building portraits' that have a literary as well as visual story. The result is a whimsical floating feel rather than a historically accurate representation.

OPPOSITE:
St Bernard's Well

Mark Making

COMBINING MEDIA #9

—

Pools of colour in neutral tones form the base layer of this image by Amy Torgeson. The artist progresses to layers of oil pastel and then switches to coloured pencil to add dynamic lines. All of her brush marks and linework was made not only with different media, but by holding the instrument a bit differently and also working at a varied pace with each medium. The piece becomes a unique map with a vast topography of marks made by the artist.

OPPOSITE:
Sketchbook,
Cuenca, Ecuador

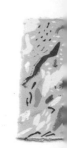
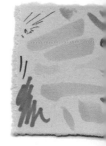
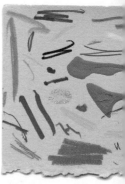

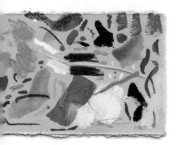

Unconventional Materials

COMBINING MEDIA #10

—

Test Images were composed over a long duration of time in Mia Christopher's studio. The assortment of zig-zags, scribbles, dashes and paint swatches are made using materials such as lipstick, latex glitter, as well as ink, gouache paint and watercolour.

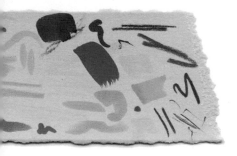

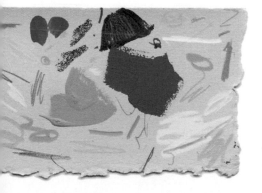

LEFT:
Test Images

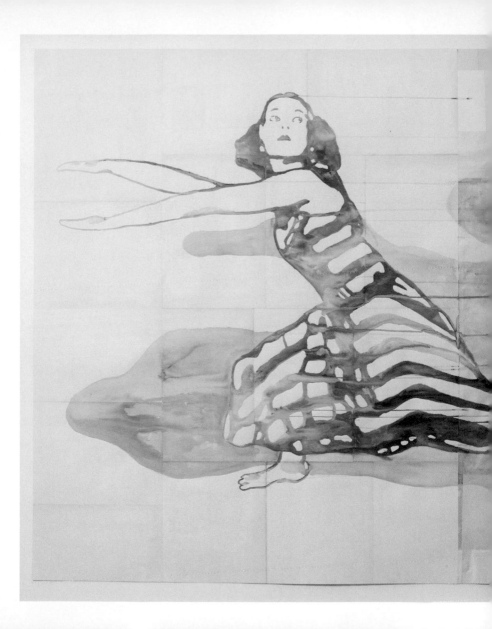

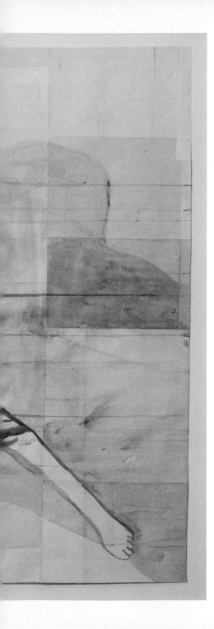

Painting on Found Paper

INSPIRATION #12
—

In *Mary*, by Ulla von Brandenburg, a woman appears to be in a performance pose; lunging deeply with arms outstretched. She is painted in prismatic hues on a grid of vintage paper. The soft and loose way the artist paints her subject feels nostalgic, which befits the antique paper it's painted on. The paper is yellowed by age and cream tones, clearly affected and changed by the application of water to it, causing it to buckle and ripple slightly.

LEFT: *Mary*

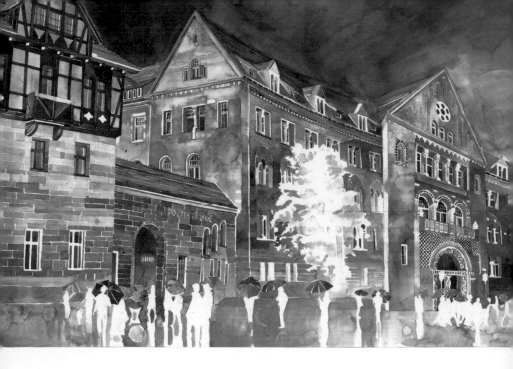

Cityscape

STYLE #13

—

On a stroll through a city centre you may observe an abundance of inspiration from the architecture surrounding you. In different cities throughout the world, structures boast many features to enjoy. Maja Wronska is passionate about capturing cityscapes with watercolours. Her background as an architect lends her work precision in the planes and lines that depict dimension and depth in delicately rendered watercolour.

ABOVE:
Sunset in Poznań

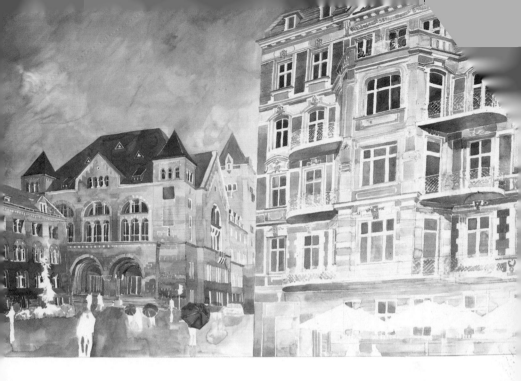

Expressive colour and brushwork in the skyline promote
a sense of enthusiasm about the architecture and less
descriptive are the white silhouetted occupants of the
city. These blank spaces also allow space for the viewers
eyes to rest. Adding tiny details to all of the figure and
objects in the foreground would visually overload
this image.

A Painting a Day

INSPIRATION #13
—

Artist Courtney Cerruti is also an author, collaborator and art supply shop owner. There is a social quality to her art that is connected to her process. She welcomes artists daily into her shop and leads an open workshop, called Social Sketch, inviting all to come and create in the company of others. Her motive to engage artists and beginners alike is the exploration of art media. The *Single Ladies* series (some of which is shown here) is the only body of work she's created that doesn't use photographic reference, but is painted entirely from imagination. 'These women are single and strong, fragile and alone, they are women I know and anonymous women. Individually they are a single history and set of experiences, but presented together they span the gamut of experience; of pain, of joy and of strength.'

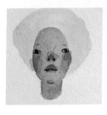

ABOVE & OPPOSITE:
Single Ladies

Circles

APPLICATION #11

—

This cluster of circles by Yao Cheng demonstrates how the layering of different transparencies can turn a simple motif such as circles into an eye-catching image. The airy whimsical feeling is conveyed through the use of a primary colour palette. Hues of red, blue and yellow are mixed only with water to produce the range of semi-transparent to bold-and-vivid circles. The focus is on blends and bleeds occurring in her simple shapes to add layers of translucent shapes which indicate depth and also add interest.

OPPOSITE:
*Cluster in Magenta
& Turquoise*

Watercolour, Coffee and Beeswax

TEXTURES #6
—

In this piece by Teresa Crowder the combination of watercolour, coffee and beeswax creates a multi-layered, tactile experience. The different materials are at times transparent, other moments opaque, all the while tempting you to touch-test the smooth matte areas of rich colour.

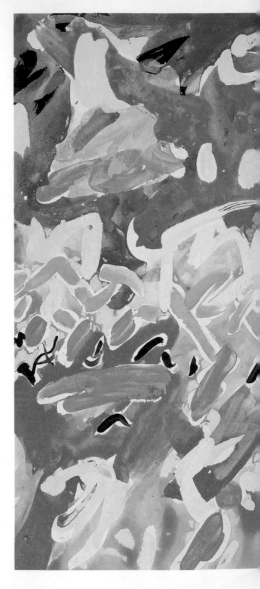

RIGHT:
The Sky Beat the Dream: Horn Island

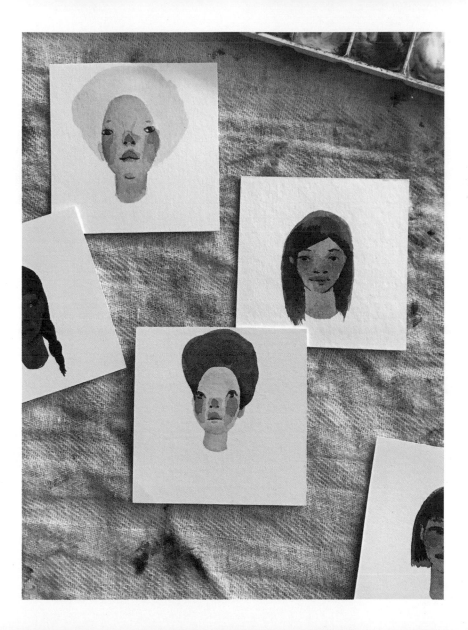

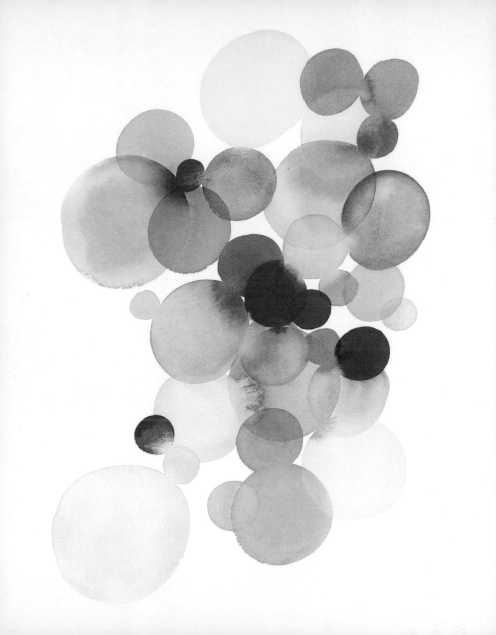

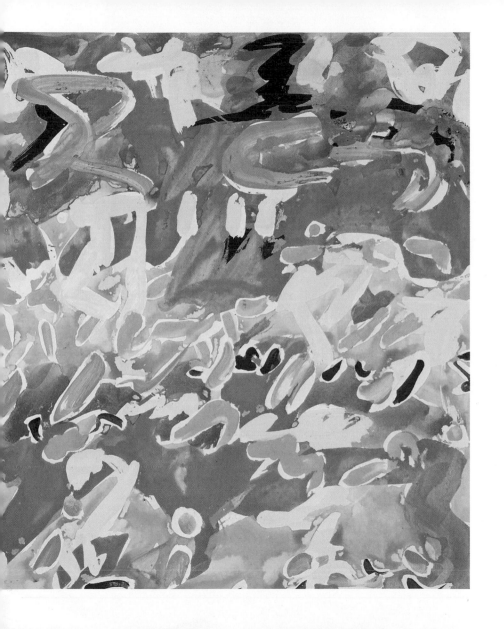

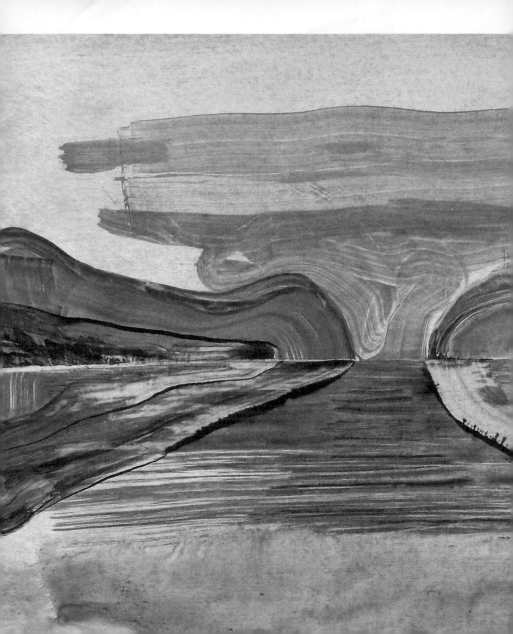

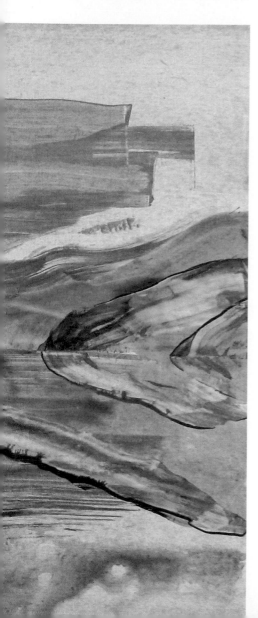

Watercolour Monoprints

COMBINING TECHNIQUES #6

—

Monoprints are produced by transferring layers of painted brush strokes, one on top of the next, through multiple turns on a printing press. Deborah Freedman uses various brush strokes to paint watercolour paintings on vellum. She manipulates the pigments on the vellum by using spray bottles, rollers and pieces of cardstock to spread pigments. Central to her composition is the horizon line, which indicates where sky meets land. The foreground is made up of a body of water reflecting land masses indicated in the middleground of the composition.

LEFT:
With or Without 5

Sketchbooking

INSPIRATION #14

Working in a sketchbook is an
immediate way to commit ideas to
a page, and for Amy Torgeson it is a
welcome companion when travelling
abroad. This image was created while
Amy was travelling through South
America with family and it preserves the
sensations or surroundings that inspired
her. Bring just enough source materials
and supplies with you to create when
inspiration strikes.

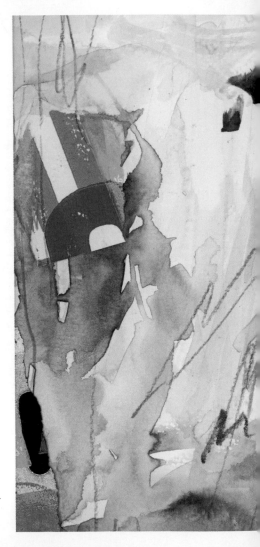

RIGHT: *Sketch Jungle,*
excerpt

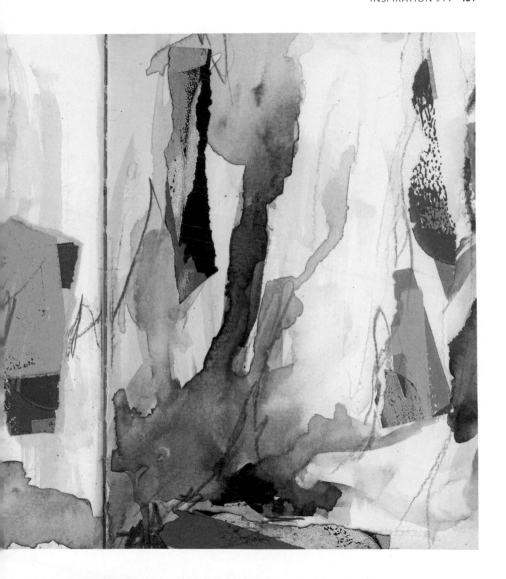

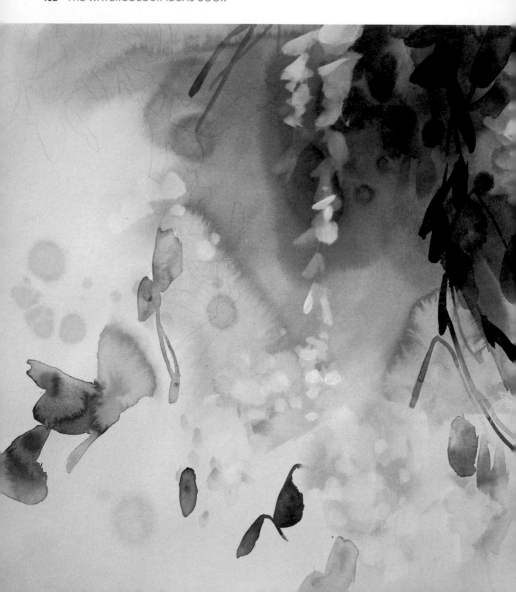

Cyanotype

TECHNIQUE #13

—

In this painting, *Shadow Play*, artist Elise Morris is inspired both by botanical painting and cyanotypes. A cyanotype is a print made from a photochemical process that produces a vibrant blue image. In the upper-right section of the painting, the artist indicates white silhouetted leaves and petal shapes, as though illuminated like a delicate x-ray on an indigo backdrop. Elise paints with quite a bit of water added to acrylic paint, creating translucent effects similar to watercolour.

OPPOSITE:
Shadow Play

Influenced by Geometry

APPLICATION #12

—

Exercise your brush strokes to recreate effortless geometric forms like Kim Wiessner. The artist takes a cue from semi-circles, triangles and ninety-degree angles. She applies slow, steady bands of colour of varying translucency in side-by-side washes. Kim is dedicated to her colour schemes, and she spends a great deal of time meticulously planning her palette before executing these geometric shapes.

OPPOSITE:
Pivot in Sea and *Smoke*

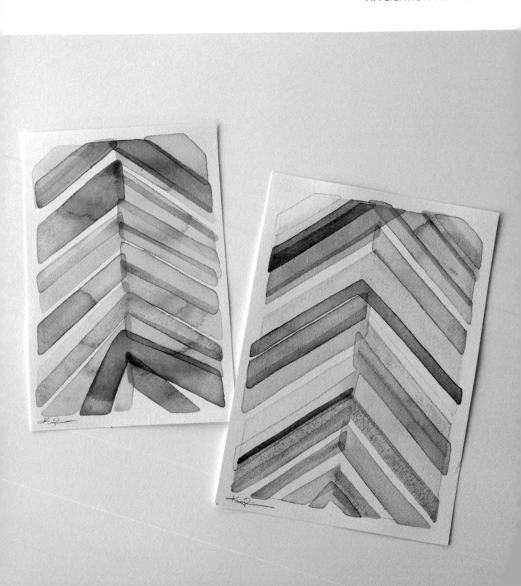

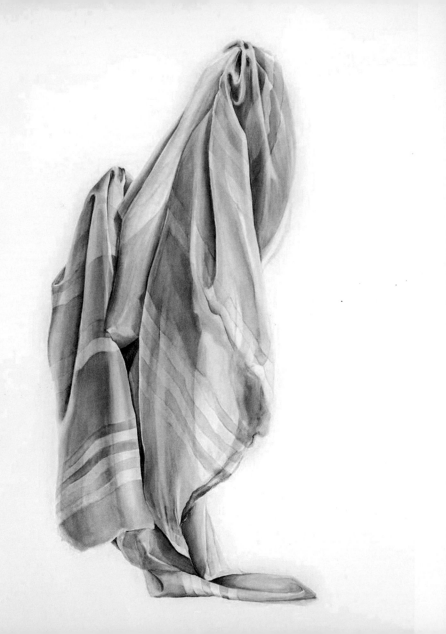

Recreating Fabric

TECHNIQUE #14

—

Recreating the texture and folds of fabric is a wonderful way to utilise the delicate qualities of watercolour. A light source on your subject helps to make all of the subtle colour shifts in the wrinkles and folds stand out. In *Fictitious Coverage*, Jennifer Shada begins by laying down an underpainting of grey values to serve as a map for executing colour value later. The deepest folds, where the least amount of light touches are darkest, followed by a range of lighter areas throughout the fabric. Follow the turquoise stripes and you will see that the lightest areas are directly in the light source, becoming slightly darker on the reverse side of a wrinkle. The boldest areas are furthest from a light source, but closest to the viewer.

OPPOSITE:
Fictitious Coverage

Marker and Watercolour

COMBINING TECHNIQUES #7

—

Notice the contrast in the way the details of the vase of flowers compare with the backdrop. The thin bold lines of the stems stand out in vibrancy and opacity. The marker is a nice complement to the smooth flat areas of watercolour, which is a natural translation of details in the foreground being sharper than those in the background. The pairing of these materials is a part of Kate Lewis' visual vocabulary as she often captures her flower subjects with markers. Often set in domestic quarters, living rooms and dining room tables, the backdrops are largely washed with watercolour to replicate patterns on the wallpaper or the colours of painted interiors.

OPPOSITE: *Flowers in Green Vase on Blue*

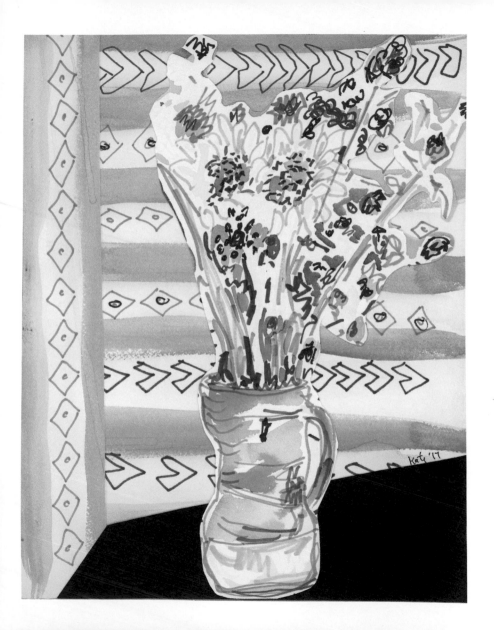

An Artist's Book

INSPIRATION #15
—

Small artist books are a special compilation of artwork. *Kinomatti Book* by Jenni Rope is an interactive, movable work of art to be experienced by the viewer. Several cut-out circles on watercolour-pigmented pages are bound together with thread. The author executes both a tactile and visual play in her book by cutting the circles smaller and smaller as you progress further into its pages.

RIGHT:
Kinomatti Book

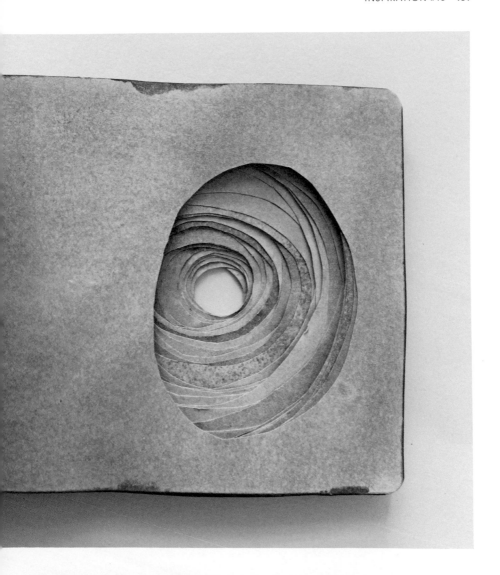

Painting as Process

TEXTURES #7
—

With its small radiating open spaces, this circular painting bears much resemblance to a crocheted doily. The spiral form is inspired by artist Chelsea Hopkins-Allan's love of recreating patterns from nature, such as a spider's web or seashells. The gradual shifts in colour and the tiny repetitive negative spaces are worthy of close inspection, while as a whole the piece has a very striking design. The artist is also influenced by mandalas, or circular sacred emblems relevant to many cultures. Her meditative paintings are an exercise in mindfulness and are loosely intended to serve as a visual tool to focus your mind.

LEFT & OPPOSITE:
Crochet Web Mandala No. 128 and *Crochet Web Mandala No. 131*

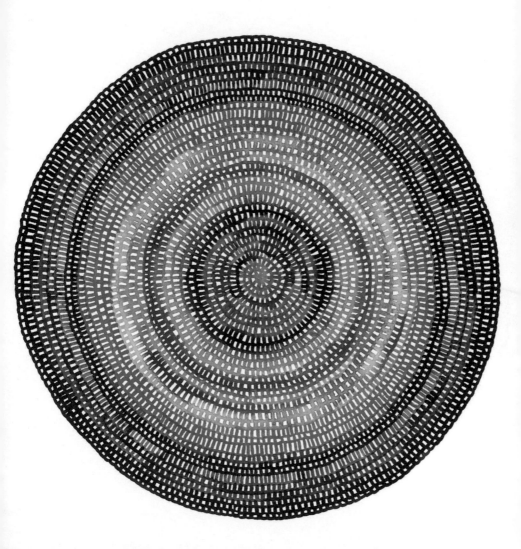

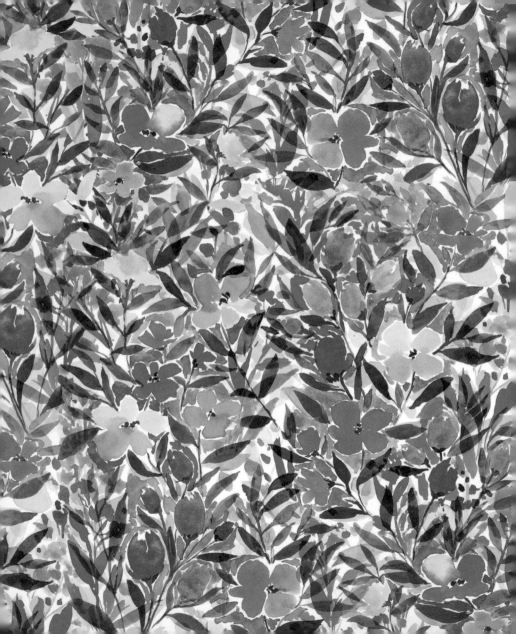

Surface Design

INSPIRATION #16

—

Take a cue from textile designs on a favourite top, a printed tablecloth, or bedspread and feel inspired to create an original pattern. Create a striking design scheme of your own by choosing a colour palette and painting with distinctive marks or appealing shapes. Think of how it will translate as a repeated design on a surface. This idea may lead you to wonder who designed all of the patterns that inspire you most. Many artists today are working creating original art as highly influential surface designers, such as Jacqueline Maldonado.

OPPOSITE:
Nonchalant (Coral)

Botanical Painting

STYLE #14

—

Botanical paintings are a tradition in which artists study and catalogue plant subjects. Here, artist Yao Cheng illustrates the fruit-bearing branches of a peach tree. The peaches are painted with a wet-in-wet technique that effortlessly blends hues of orange, yellow and red. Swift flat strokes from the artist's brush are used to shape surrounding leaves, which in turn accentuate the roundness of the luminous fruits. You can achieve clean rounded edges like these by first laying down circles with water. While your circle is wet on your page, paint in one pigment at a time and watch as backwashes mix colours and mimic the same variations found in nature.

OPPOSITE:
Peach Harvest

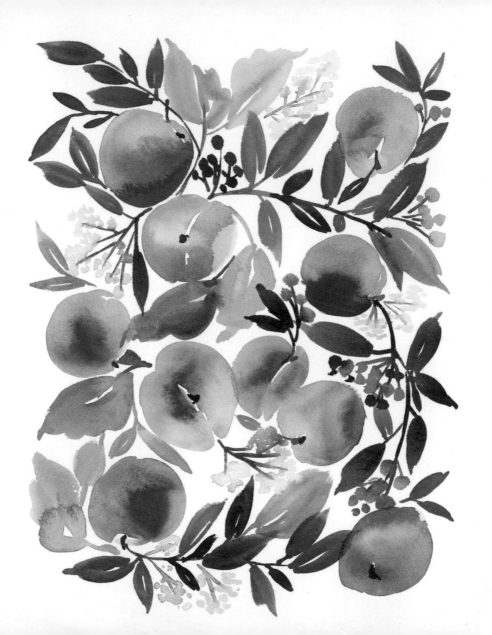

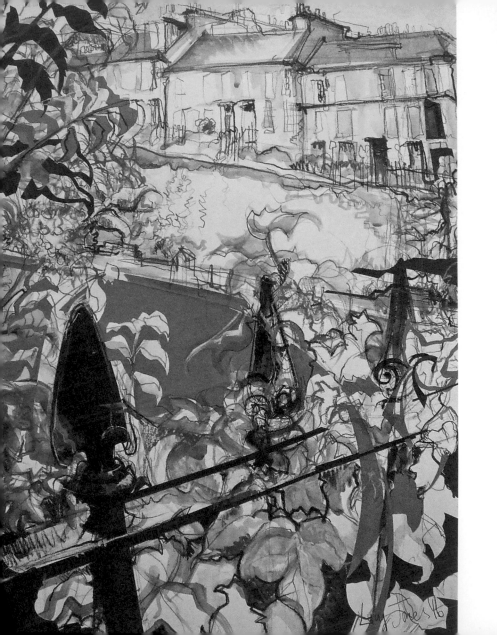

The Rule of Thirds

TECHNIQUE #15

—

When crafting a composition one tip to consider is the rule of thirds. If you were to imagine your painting of a landscape set upon a grid of nine evenly distributed sections, there are intersectional points at which details or features are best placed for adding interest and making your composition more pleasing to the eye. The vertical composition in *Upper Dean Terrace*, by Lucy Jones, demonstrates this principle well. The lower third of the painting is dominated by the diagonal lines in the gate, mirrored in the topmost third by the line of the street. These lines guide you around the picture, while creating a pleasing balance. At the same time, Jones's use of colour – stronger in the gate, and with bold, heavy marks; fainter in the architecture – generates the illusion of depth and distance in the piece.

OPPOSITE:
Upper Dean Terrace

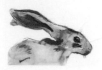

ALISA ADAMSONE
P114–115
www.saatchiart.com/
alisaadamsone

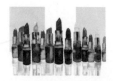

VERONICA BALLART LILJA
P58–59, P116–117
www.saatchiart.com/
veraballart

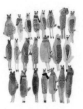

MARION BARRAUD
P96–97, P100–101
http://marion-mmm.
blogspot.co.uk

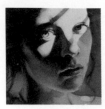

MARCOS BECCARI
P54–55
www.marcosbeccari.com

MIKE BISKUP
P64–65
www.mikebiskup.com

ELENA BLANCO
P18–19, P122–123
http://dreamyme.com

ANNABEL BURTON
P26–27
www.annabelburton.com

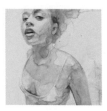

ALI CAVANAUGH
P92–93, P118–119
www.alicavanaugh.com

COURTNEY CERRUTI
P142–143
www.ccerruti.com

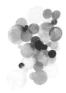

YAO CHENG
P22–23, P68–69, P144–145,
P166–167
www.yaochengdesign.com

MIA CHRISTOPHER
P136–137
www.miachristopher.com

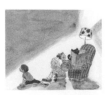

SIMONA CIRAOLO
P104–105
http://simonaciraolo.com

CLAIRE COWIE
P48–49
www.clairecowie.com

TERESA CROWDER
P146–147
www.teresacrowder.com

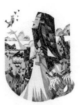

JONATHAN EDWARDS
P110–111
www.jonathan-e.com

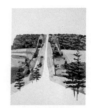

KATE EVANS
P102–103, P130–131
www.kateevansgallery.com

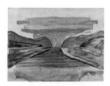

DEBORAH FREEDMAN
P148–149
www.deborahfreedman.
com

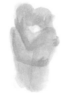

FRANCOIS HENRI
GALLAND
P120–121
http://francoishenrigalland.
com

EMILY GRADY DODGE
P20–21, P80–81
www.emilygradydodge.
com

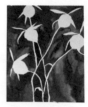

SUSAN HABLE
P108–109
www.susanhable.com

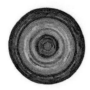

CHELSEA HOPKINS
ALLAN P162–163
www.chelseahopkins-allan.
com

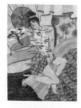

BODIL JANE
P7, P44–45
www.bodiljane.com

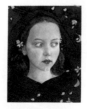

TERESA JENELLEN
P74–75
http://teresajenellen.com

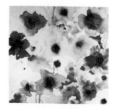

KARIN JOHANNESSON
P126–127
www.karinjohannesson.
com

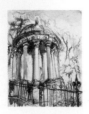

LUCY JONES
P132–133, P168–169
www.lucyjonesart.com

NANCY LOUISE JONES
P98–99
www.nancylouisejones.
com

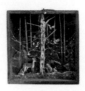

ALLISON MAY KIPHUTH
P70–71, P128–129
www.allisonmaykiphuth.
com

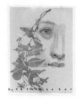

ANNIE KOELLE
P32–33
www.anniekoelle.com

JEN LASHEK
P52–53, P78–79
https://jenlashek.com

KATE LEWIS
P36–37, P158–159
www.katelewisart.com

SHELBY R LING
P124–125
www.shelbyling.com

**JACQUELINE
MALDONADO**
P164–165
www.
jacquelinemaldonado.com

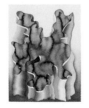

JUSTIN MARGITICH
P42–43
http://justinmargitich.com

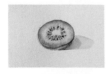

HEATHER MCCAW KERLEY
P86–87, P90–91
www.heathermccawkerley.
com

ELISE MORRIS
P60–61, P152–153
www.elisemorris.net

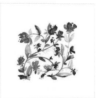

KIANA MOSLEY
P10–11, P28–29
www.saatchiart.com/
KianaKeiser

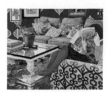

NAOMI OKUBO
P82–83
https://nyaooon.jimdo.
com

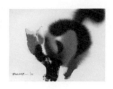

ENDRE PENOVÁC
P30–31
www.penovacendre.com

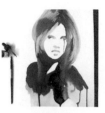

STINA PERSSON
P8–9, P88–89
www.stinapersson.com

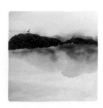

FABIENNE RIVORY
P72–73
http://labokoff.fr

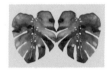

KATE ROEBUCK
P12–13, P94–95
www.kateroebuckstudio.
com

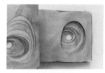

JENNI ROPE
P160–161
www.jennirope.com

MALISSA RYDER
P38–39
www.malissaryder.com

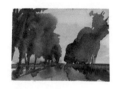

REBECCA RYLAND
P84–85
www.rebeccaryland.com

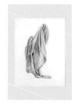

JENNIFER SHADA
P156–157
www.jennifershada.com

E.H. SHERMAN
P66–67
www.ehsherman.com

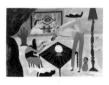

NICHOLAS STEVENSON
P34–35
www.nicholasstevenson.
com

RHIAN SWIERAT
P76–77
www.rhianswierat.com

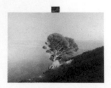

MARZIO TAMER
P46–47
www.salamongallery.com/
bio.php?codice=4

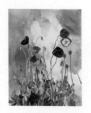

RANDALL DAVID TIPTON
P62–63
www.randalldavidtipton.
com

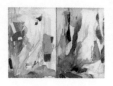

AMY TORGESON
P106–107, P134–135,
P150–151
www.amytorgeson.com

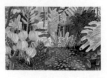

JENNIFER TYERS
P24–25
http://jennifertyers.com

ULLA VON BRANDENBURG
P40–41, P138–139
www.pilarcorrias.
com/artists/ulla-von-
brandenburg

HELEN WELLS
P16–17
www.helenwellsartist.co.uk

MIA WHITTEMORE
P112–113
http://miawhittemore.com

KIM WIESSNER
P14–15, P154–155
www.tinywatercolors.com

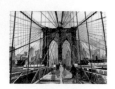

MAJA WRONSKA
P50–51, P140–141
www.majawronska.com

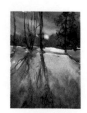

SARAH YEOMAN
P56–57
https://sarahyeoman.com

Joanna Goss embraces playfulness and joy in her delightful and original watercolours. Her unmistakable style and contemporary pattern-based paintings have earned her recognition from across the web. The bright, vibrant designs she creates continually lend themselves to unique applications. From custom stationery to textiles, Goss' nostalgic and of-the-moment sensibilities have landed her retail lines with top national brands. In addition to her popular patterns, she is known for painting colourfully whimsical portraits of people and animals.

ACKNOWLEDGEMENTS

—

I would like to thank each and every artist who has allowed me the chance to point out their amazing work in this book.

Sincerest thanks to my publisher and editor who presented me with this opportunity and for being a perfect guide along the way.

This book is dedicated to my Mom – who else? Her enduring influence and unquestioning support has helped fuel my pursuit of curiosity and a creative life.

PICTURE CREDITS

P7 Bodil Jane – Folio Art; 8–9 Stina Persson; 10–11 Kiana Mosley; 12–13 Kate Roebuck; 14–15 Kimberly Wiessner; 16–17 Helen Wells Artist www.helenwellsartist.co.uk; 18–19 Elena Blanco, Artist and Illustrator; 20–21 Emily Grady Dodge; 22–23 Yao Cheng © Yao Cheng Design 2017 www.yaochengdesign.com; 24–25 Jennifer Tyers; 26–27 Annabel Burton; 28–29 Kiana Mosley; 30–31 Endre Penovác www.penovacendre.com; 32–33 Annie Koelle www.anniekoelle.com; 34–35 Nicholas Stevenson; 36–37 Kate Lewis; 38–39 © Malissa Ryder; 40–41 Ulla von Brandenburg; 42–43 Justin Margitich; 44–45 Bodil Jane – Folio Art; 46–47 Marzio Tamer, Courtesy Salamon, Milan; 48–49 Courtesy of the Artist Claire Cowie and Elizabeth Leach Gallery; 50–51 Maja Wronska www. majawronska.com; 52–53 Jen Lashek; 54–55 Marcos Beccari www.marcosbeccari.com; 56–57 Sarah Yeoman; 58–59 Veronica Ballart Lilja; 60–61 Elise Morris; 62–63 Randall David Tipton www.randalldavidtipton.com; 64–65 Mike Biskup www.mikebiskup. com; 66–67 E.H. Sherman; 68–69 Yao Cheng © Yao Cheng Design 2017 www.yaochengdesign.com; 70–71 Allison May Kiphuth; 72–73 Fabienne Rivory; 74–75 Teresa Jenellen; 76–77 Rhian Swierat; 78–79 Jen Lashek; 80–81 Emily Grady Dodge; 82–83 Naomi Okubo, courtesy of GALLERY MoMo; 84–85 Rebecca Ryland; 86–87 Heather Mccaw kerley; 88–89 Stina Persson; 90–91 Heather McCaw kerley; 92–93 Ali Cavanaugh www.alicavanaugh.com, @_alicavanaugh_; 94–95 Kate Roebuck; 96–97 Marion Barraud; 98–99 Nancy Louise Jones; 100–101 Marion Barraud; 102–103 Kate Evans; 104–105 Illustration © 2014 Simona Ciraolo; 106–107 Amy Torgeson; 108–109 Susan Hable; 110–111 Jonathan Edwards; 112–113 Mia Whittemore; 114–115 Alisa Adamsone @adamsoneart; 116–117 Veronica Ballart Lilja; 118–119 Ali Cavanaugh www.alicavanaugh.com, @_alicavanaugh_; 120–121 Francois Henri Galland; 122–123 Elena Blanco, Artist and Illustrator; 124–125 Shelby R Ling; 126–127 Karin Johannesson; 128–129 Allison May Kiphuth; 130–131 Kate Evans; 132–133 Lucy Jones www.lucyjonesart.com; 134–135 Amy Torgeson; 136–137 Mia Christopher; 138–139 Ulla von Brandenburg, Courtesy of the Artist and Pilar Corrias Gallery; 140–141 Maja Wronska www. majawronska.com; 142–143 Courtney Cerruti; 144–145 Yao Cheng © Yao Cheng Design 2017 www.yaochengdesign.com; 146–147 Teresa Crowder; 148–149 WITH or WITHOUT 5, Artist: Deborah Freedman, Printer: Sue Oehme; 150–151 Amy Torgeson; 152–153 Elise Morris; 154–155 Kimberly Wiessner; 156–157 Jennifer Shada; 158–159 Kate Lewis; 160–161 Jenni Rope; 162–163 Chelsea Hopkins-Allan; 164–165 Jacqueline Maldonado; 166–167 Yao Cheng © Yao Cheng Design 2017 www.yaochengdesign. com; 168–169 Lucy Jones www.lucyjonesart.com